My Time To Color

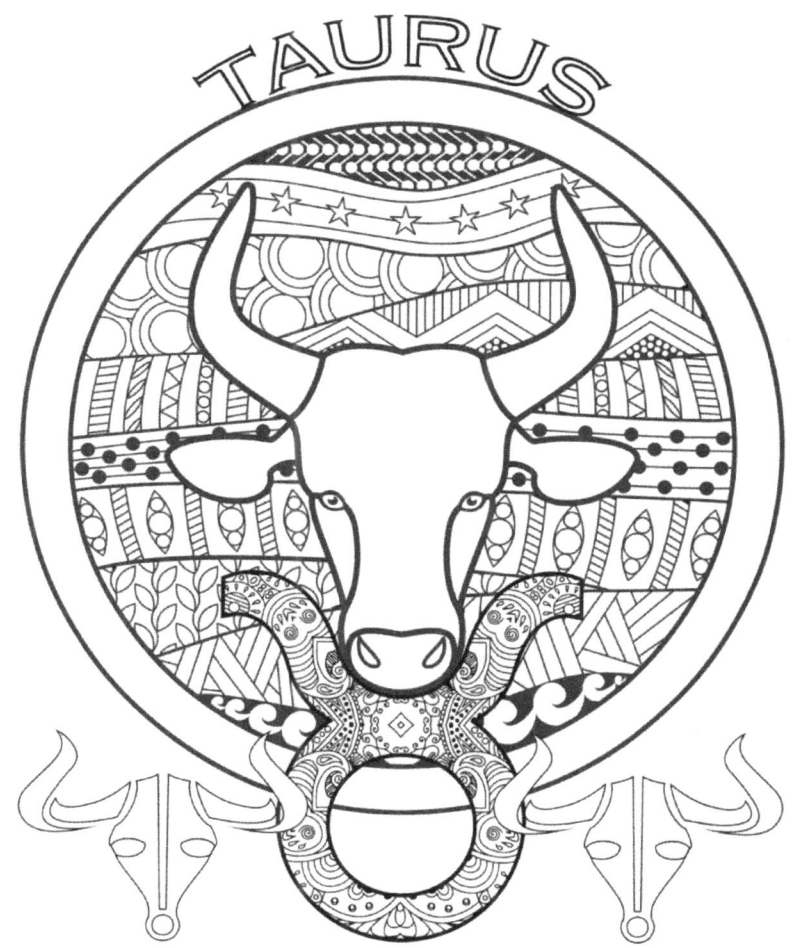

Taurus Zodiac Sign

Coloring Book

Updated 2018 Edition

Copyright 2017 –

Swift Publishing/MyTimeToColor.com

All Rights Reserved

Images May Not Be Replicated or Reproduced

Some design elements/images used under license
from Shutterstock. Some design elements designed
by Freepik from FlatIcon.com.

ISBN-13: 978-1545321669

ISBN-10: 1545321663

Taurus

This book belongs to

Birth Date

BORN ON THE CUSP?

Your zodiac sign is based upon the position of the Sun when you were born. At the time and place of your birth the Sun was in a specific position and therefore within a specific zodiac sign. While it would be more convenient if the Sun's transition from one sign to another happened exactly at midnight on any given day, it doesn't. Plus there are many various time zones throughout the world, so your midnight would not be the same as midnight for someone in a different time zone.

In addition, a calendar year is not the same as the Earth's annual revolution (circling) of the Sun. The actual length of a sidereal year (time required for Earth to revolve once around the Sun) is actually 365.25635 days. That is why every four years there is a leap year of 366 days to compensate for the error caused by the calendar year being shorter than the sidereal year.

This is why the Sun can be in different zodiac signs on the same calendar day in different years. The start and end dates of the zodiac signs can and do vary from year to year.

In reality the Sun was in one specific position, and therefore one specific sign, when you were born. Before the age of computers it used to be very time consuming to determine your sign if you were born on the cusp (near the beginning or end of a sign).

Now there are online calculators that you can use to make this determination. You will get the most accurate results if you have all three of these: 1) your day of birth 2) your time of birth and 3) your place of birth. Most calculators will still allow you to calculate your sun sign without your time of birth but the determination could be off. Input these three items into an accurate online sun sign calculator and you will be able to confidently determine your Sun sign.

This web page has an online calculator for determining your sign:
www.MyTimeToColor.com/sign

ZODIAC SUN SIGN TAURUS

April 21 to May 21 (* see 'Born on the CUSP?')

Symbol:	Bull

Element:	Earth

Quality:	Fixed

Ruling Planet:	Venus

Lucky numbers:	5 and 6

Color:	Pink

Favorite Environment:	Quiet places

Governs:	Thyroid, Throat

Best Pet:	Turtle

Flowers:	Roses, Poppies

WHAT IS ASTROLOGY?

Astrology is the use of heavenly bodies to guide us in our lives. It is based on the belief that the stars and planets have a direct impact on our lives and that their relative positions to each other predict certain events. Most people know astrology from their horoscopes and some characteristics of their Zodiac sign, but there is much more to it. You can gain a deeper knowledge of astrology and use it to improve your life.

There are twelve Zodiac signs. Your day and time of your birth determines your zodiac sign. Each Zodiac sign also has a quality, an element, and a ruling planet (or two). For example, if you were born November 14th, (like me!) your sign is Scorpio, your element is Water, your quality is Fixed, and your ruling planets are Pluto and Mars. Each of these pieces of astrological information give you useful knowledge about yourself and how you will interact with people of different Zodiac signs.

History of Astrology

Astrology has a rich history and has arisen independently in many civilizations throughout the centuries. Ever since the rise of humans, people have been observing the stars and planets. Knowledge of these bodies increased drastically with writing to record patterns that took place over long periods of time. Astrology first originated with the Babylonians about 4,000 years ago, when they began to use the stars to predict seasonal and astronomical events.

Since there are 12 lunar cycles in a year, they associated a constellation with each cycle, one that was always in the same part of the sky during that cycle. They then named these constellations after animals and gods. These constellations could be used to tell somewhat reliably what was about to happen with the weather, so we have the stars predicting the future. Astrology! They also believed that when a planet that represented a god gave bad omens, it meant that god was angry. They then attempted to appease it to protect the king and their nation, which meant they believed in a two-way interaction between the movements in the sky and the actions of humans.

The Chinese developed their own system of astrology, with twelve Zodiac signs based on animals representing the years in which they were born, and five elements. Confucius believed in astrology, saying, "Heaven sends down its good or evil symbols and wise men act accordingly." They believed that the stars and planets predicted the rise and fall of dynasties.

Astrology Brings Understanding

People today use astrology to understand their personality better and know what their strengths and weaknesses are. They can use horoscopes to know when there may be upcoming challenges or opportunities. Your response to your environment is determined by personality, and an important factor in your personality is your Zodiac sign and its corresponding quality and element. Therefore, astrology can explain how you will respond in certain situations. This understanding can be used to your advantage or, at the very least, help you to know that it's just the way you are.

For example, someone with the Fixed quality (Taurus, Leo, Scorpio, Aquarius) will often be uncomfortable in times of great change in their life. They could use this knowledge to realize why they are upset and then strive to regain a routine in life. Astrology offers certain psychological insights that are the accumulation of centuries of knowledge. These can be a powerful help in times of uncertainty.

It is important to remember to act decisively when faced with good fortune or looming catastrophe. The planets and stars will not live your life for you, however much they may influence your life. If you do not use the knowledge astrology provides, you have gained nothing.

Using Astrology in Personal Relationships

As it is a matter of great importance to many people, astrology has become highly refined in providing knowledge about significant others. Horoscopes often include advice or predictions involving your lover or crush. You can use your Zodiac sign in dating to have an idea ahead of time how a relationship would work with someone, based on their Zodiac sign and how yours interacts with it.

The relationship between two signs may be likely to work out because of shared interests and personality. Or it could be a cause for conflict, breeding misunderstanding and resentments. However, a good matchup between signs is no guarantee of a successful relationship, nor is a bad matchup a sure omen of a doomed one. Understanding your partner's astrological traits can help you to understand why your partner sees things and reacts to things the way they do. This can lead to more joyful times for both and it can help when working through conflicts. These sign interactions are a general guide to be used with consideration of other factors.

Astrology is helpful when it comes to interacting with your family. Understanding the characteristics of the signs for each of your family members can give insight on their words and deeds. You can learn about why there may be chronic conflict between two family members. You can use it to see an issue from the other point of view, which tends to decrease frustration and hostility. Reading horoscopes to family members can be a fun bonding activity.

For friends, astrology can be used to seek out the friendships most likely to succeed and to know why conflict arises and when that conflict may be irreconcilable, signaling it's time to move on. It can be used to understand the different mindsets of your friends and to know which ones would be best to undertake a project or go on a trip with.

Some signs have very different priorities and knowing and accepting the differences in your friend's motivations can be therapeutic. It can be very discouraging when you are excited about an idea and a friend shoots it down. It may be for a good reason, or it might be just because they have a different sign and mindset. In this case, it's best to share the idea with a friend of a more compatible sign.

ELEMENTS IN ASTROLOGY

The ancient Greeks believed that the world was composed of four elements: fire, earth, air, and water. Everything was a mixture of different amounts of these four elements. These four basic elements are no longer believed to be building blocks of our world, but they remain significant in astrology. In the same way that it was believed objects were composed of the four elements, it is now believed in astrology that the four elements make up our personalities. Each element has certain personality traits, and each sign has a unique mixture of these traits.

"China's Five Elements Philosophy" on chinahighlights.com explains that elements were first associated with zodiac signs in China in the Spring and Autumn period between 770 and 476 BC. Their zodiac signs are different animals, such as pig, rat, and dragon. They had five elements in traditional Chinese astrology: wood, water, earth, fire and metal. Each element was associated with 2 zodiac animals, except for Earth, which was attached to 4. As astrology spread from Asia and developed in Europe, each of the four ancient Greek elements became associated with 3 of the 12 zodiac signs.

Every person has an element, based on what their zodiac sign is.

The Air signs are Aquarius, Libra and Gemini.

The Water signs are Cancer, Pisces and Scorpio.

The Fire signs are Leo, Sagittarius and Aries.

The Earth signs are Capricorn, Virgo and Taurus

Your element affects you in many ways. It indicates certain personality traits that you have and explains how you will handle different situations. Your element is compatible with certain elements, so knowing your element can help you to find friends and lovers who are more likely to get along with you. Your element says a lot about what your strengths and weaknesses are and what kind of person you are. You can use this knowledge to play to your strengths and watch out for your weaknesses.

AIR

People whose sign is attached to the air element are intellectual; logical rather than emotional. They are witty, clever, and outgoing. They are excellent communicators because of their precise thinking. Because they are less reliant on emotion, they can remain calm and calculating in stressful situations.

They are most compatible with air, fire, and earth elements. They can have trouble with people of the water element because of the conflict between their calm logic and water's strong emotion. To bridge this gap, they need to speak the other's language, the language of feelings.

The heavy thinking that comes with the air element can be good or bad. With the Gemini, it causes indecisiveness due to over-analyzing things, but this prevents rash decisions. With the Aquarius, it means thinking about making things better far in the future, but this can cause their head to be in the clouds at times that require practicality. For the Libra, much of the thinking is about other people, but this can be expressed in either empathetic thoughts, or worrying about what other will think of them. Those with the air element would do well to remember that the world is not inside their head and that not everyone thinks as much as they do. However, their powers of intelligence are sure to serve them well in life.

WATER

Those whose sign connects with the water element are adaptable, emotional, and sensitive. They are deep and creative and they have great powers of imagination. They are in tune with the feelings of others and their observant qualities allow them to catch the subtle cues that a person in distress displays. They can be possessive and their knowledge of others emotions can be used for either nurture or manipulation.

The water element is most compatible with water and earth. For those of a water element dealing with people of the fire element, they should wear a thick skin and be ready to not take the fire element's occasional bursts of anger personally. They must remember that fire is impulsive and be patient with these people.

Those who are defined by the water element have strong emotions, and emotions can be powerful and difficult to control. However, emotion is a guiding force in our lives and shows us how to react to different circumstances.

A Cancer is loyal and very emotionally attached to their family, which is why it is good to be closely associated with a Cancer. A Cancer may overreact to perceived insults to their loved ones because they are so protective. The Pisces is friendly and altruistic, and rarely judgmental, but this faith in humanity may lead to them being taken advantage of, which causes many a Pisces to become depressed. Pisces are prone to sadness, but this also gives them an insight into the suffering of others, creating empathy with those in need. The Scorpio is brave and passionately attached to what they believe to be true. This can cause them to fight for something good, or if they are mistaken in their beliefs, to be a powerful force for evil. Their suspicious nature can protect them, but also make them paranoid, and therefore emotionally unstable.

Those with water as their element can overcome any weaknesses associated with emotionality by taking a time-out from the situation. A powerful emotion is like a strong fire, very hot, but quick to burn its fuel and end.

FIRE

Which brings us to the fire element! Those whose signs are attached to the fire element are energetic, impulsive, and enthusiastic. Their liveliness is inspiring and they make great leaders because of their charisma. They can also be very unpredictable and have a temper; they will be forceful when triggered. Adventurous and quick to try new things, people of the fire element are often groundbreakers and innovators. They stick with what their gut tells them and are very decisive.

Fire people are most compatible with air and fire people. When they deal with those of the earth element, they may become irritated with how grounded and practical they are and consider them boring. In this case, a fire person should keep their ego in check and realize that stable people are just as necessary as the impulsive ones.

The energy and charisma of people under the fire element can lead to a wide variety of outcomes. For the Aries, their energy is expressed in their speed and competitiveness. This impatience can lead to greatness, or frustration and anger. They always want to be first, and although they are very organized, their tendency to race through things can trip them up. For the Leo, their charisma leads to unparalleled leadership abilities. But they can also have a large ego and be stubborn and self-centered. Their ability to get their way from others means they might not address these issues, because they won't need to. When it comes to the Sagittarius, part of their charm is their uncompromising honesty. Their trustworthiness attracts people, but it can also drive them away if a Sagittarius says something brutally honest that hurts someone's feelings.

EARTH

The people whose sign is associated with the earth element can truly be described as down-to-earth. They are practical, emotionally stable, and reliable. They are not risk-takers nor are they prone to idealistic ambitions. Instead, they are focused on steadily making improvements in their lives and the lives of those they love. They are materialistic and intent on accumulating money and property.

Earth gets along best with earth and water. To get along with the fire element, earth people shouldn't try to save these impulsive risk-takers from failure, because they won't listen.

The stability and materialism of the earth element has predictable results. The Taurus is reliable yet stubborn and will be conservative in their life choices. They are good at making money, but they can also become greedy because of money's addictive properties. The Virgo does things systematically and never leaves anything undone. They are highly organized but this means they are prone to perfectionism. They can be judgmental of anyone who lacks their attention to detail, which may hurt someone's feelings. The Capricorn is disciplined and self-reliant. They are fond of tradition and value experience over experiment. Their commitment to tradition can lead to stubbornness and they often expect innovations to fail. Their faith in the tried and true can be utterly unshakeable.

ASTROLOGICAL QUALITY

In Astrology, there are 12 signs of the Zodiac. Each of these signs corresponds to one of three qualities: Cardinal, Fixed or Mutable. The qualities are also called quadruplicities because they each describe four of the Zodiac signs. Each quality has certain characteristics that correspond to the position in the season of the zodiac sign. The Zodiac signs that begin each season have the Cardinal quality, or "initiating energy". The Zodiac Signs in the middle of each season have the Fixed quality, or "maintaining energy". Finally, the Zodiac signs at the end of each season have the Mutable quality, or "changing energy".

Your quality says a lot about you and is an important addition to the self-knowledge astrology can provide. A person's quality determines both the inner energy of a person and how they respond to changes in their environment. It explains whether or not they are likely to change their opinions and how likely they are to be a leader or a follower. Knowing your quality can help you play to your strengths and realize what weak points in your energy you need to strengthen. Knowing where one needs improvement can be a path to greatness! Use this knowledge of qualities to achieve greater balance in your life.

Cardinal

At the beginning of each season are the four Zodiac signs with the Cardinal qualities: Aries, Cancer, Libra and Capricorn. These signs usher in the new season and get its momentum started up. Accordingly, people with the Cardinal quality love to start new things; they are innovators and trailblazers. They tend to be ambitious and energetic, eager to start new things. They seem to have endless drive towards accomplishing things, but they often don't finish what they start, because they get so excited about something new that they move on to that!

To go along with their ambition, those with the Cardinal quality can also have a large ego. A big ego is sometimes assumed to be a bad thing, but large egos come with

confidence and the self-assuredness of leadership. They want to be the best at everything and work hard to get there. They are creative-types and innovators; trendsetters that the crowd will follow. However, they can be erratic due to their constant shifting of goals, and leaving things undone can cause problems.

Those with the Cardinal quality need to focus on finishing what they start. This may mean delaying a new project they are excited about in order to finish an older one. They can also surround themselves with people of the Fixed quality who will help them reach the finish line in all the races they start. It is very important that Cardinal quality people learn to finish their projects because of how valuable what they begin to create is!

Fixed

In the middle of each season are the four Zodiac signs with the Fixed quality: Leo, Taurus, Aquarius and Scorpio. If we compare those with the Cardinal quality to the hare who takes a nap because he is so far ahead in "The Tortoise and the Hare", we can say that those with the Fixed quality are like the tortoise. They prove that slow and steady wins the race. They have an innate ability to focus and stay committed. They are determined to reach their goals and will be persistent when faced with obstacles. People with the Fixed quality are the ones who get the job done, no matter how difficult or long the journey may be.

Fixed quality people prefer a predictable routine. Once they come to accept an idea or way of thinking, it is very hard or even impossible to get them to change their belief. This can be a strength, such as when they have an important moral belief that those around them have abandoned. It can also be a weakness when they refuse to adapt to new information. Fixed quality people are self-reliant but stubborn.

The best way for Fixed people to overcome their weakness is to open their mind and realize that they do not know everything. The entire universe is not already in their head and they need to be ready to accept new things. There is a Buddhist saying, "You cannot fill a cup that is already full." In this context, this means that when a Fixed

person's mind is filled with beliefs that they won't let go of, there's no room to allow new beliefs to come in. Anyone with the Fixed quality should welcome the experience of being proven wrong and take advantage of the opportunity for growth that it offers.

Mutable

At the end of each season are the four Zodiac signs with the Mutable quality: Gemini, Virgo, Sagittarius and Pisces. These signs come at the end of the season, when weather is changing to make way for the new season. That's why the Mutable quality is the quality of change and adaptation. People who are Mutable are quick to follow the crowd and adapt to changes in their environment. This adaptability is extremely important for times of radical change; while those who are stuck in their ways are having problems, the Mutable people will already be back in stride.

Mutable quality people can be shallow, with no deep attachments to any principle, idea or way of life. This can be useful, as some people allow their beliefs to prevent them from seizing an advantage. Being opportunistic and flip-flopping has gotten plenty people ahead in life. However, doing so might get a Mutable person called out on their lack of commitment to ideals which others take very seriously. If they get caught acting different ways with different people, they will lose trust and rumors may spread.

The best way for Mutable people to make up for this weakness is to think for themselves. It's no shame to have other people's thoughts in one's head and be strongly influenced by trends; absolutely none of us are original in everything we think and say. However, the Mutable quality people need to find some time to be on their own and then decide what they think. Then they should take this out into the world and stick with it. No matter what your beliefs are, not everyone will agree with them, and that's okay. Not everyone has to be like you, or even like you!

RULING PLANETS: TAURUS

Every Zodiac sign has a ruling planet. The planets are large bodies orbiting the Sun and in astrology they are believed to strongly affect the lives of humans on Earth. The exact scientific definition of "planet" differs from astrology's. For astrology, the moon and the sun are considered planets because they are large bodies in our solar system. The planets alter our destiny and interpreting their movements is one of the main functions of astrology. The position of the ruling planet for your Zodiac sign is a major part of determining your horoscope.

Where do ruling planets come from?

The idea that ruling planets are associated with people born at certain times originated with the Romans. They divided the calendar year into portions associated with heavenly bodies. The Earth was once thought to be the center of the universe. So, when the planets moved backwards and forwards in the sky, or moved faster or slower, they didn't understand that it was because of the Earth's movement. They thought the planets were trying to communicate with humans. The same way observations of the stars predicted the seasons, they thought movements of planets predicted human destiny.

Eventually, Zodiac signs began to be associated with certain months, which led to the ruling planets for months turning into the ruling planets for Zodiac signs. Some signs share a ruling planet with another sign and some signs have two ruling planets, a new one and a classic one. Signs like Aquarius have two ruling planets (Uranus and Saturn) because for ancient astrologers, the furthest planet that they knew of was Saturn. When new planets were discovered, astrologers came to a consensus that some signs would be assigned to the newly discovered planets: Uranus, Neptune and Pluto. Their previous ruling planets are also considered significant, so these signs have two ruling planets.

Venus, Ruler of Taurus

Venus, named after the goddess of love, is the ruling planet of Taurus. Venus rules over love, relationships, beauty, and money. Those ruled by Venus are fond of comfort and luxury and have a keen eye for art. Their taste in fashion is exquisite. The Venus nature in Taureans expresses itself in their constant efforts to surround themselves with beautiful things. As much as Taureans enjoy simply appreciating beauty, they prefer to own it.

Venus has a positive influence on relationships, which is why Taureans are so friendly and agreeable. They will be the peacemaker in any conflict. They have the intuitive ability to find compromises and to say just the right thing to calm people down. People ruled by Venus are affectionate, and Taureans express this through their dependability and generosity. Taureans build strong and lasting relationships by being consistent and trustworthy. Some say that Taureans give the best gifts, because they have excellent taste and plenty of money to spend.

Venus represents riches and art. Taureans can be major workaholics, to finance their love of expensive status symbols like jewelry and luxury cars. Those ruled by Venus tend to be either artists or collectors of art. They get great satisfaction from what they own; the more they have, the happier they will be. Anyone ruled by Venus could make a good argument against the sayings, "Money can't buy happiness," and "The best things in life are free." In their view, the best things in life are beautiful and expensive. This may seem shallow, but the truth is most of us want these things and Taureans work hard to get them.

SUN SIGN TAURUS

Taurus, the bull sign, is a very steady type of person who prefers predictability. They work hard to make money because they're determined to have the good things in life, for themselves and others. Taureans have a big heart and they can always be relied on for help. Taurus is an Earth sign, and has the Fixed quality, which have overlapping characteristics. Accordingly, Taurus is the most conservative sign, and Taureans exhibit both stubbornness and perseverance. Taureans rarely get angry, but when they do, watch out for the bull!

Taurus is an Earth sign

Taureans can be greedy, or misers, because they want to have a secure financial future. When it comes to investments, such as in the stock markets, Taureans will opt for the safe thing every time over the risky chance at a big gain. This principle is also at work in their love life. A Taurean will patiently develop a bond with someone and rarely rush things. In relationships, they are faithful and dependable; ideal for long-term relationships.

You can count on a Taurus, because they are the opposite of impulsive. Their practicality is useful to those around them. While other people may neglect doing ground work because they consider it boring or hard, the Taurus person will make sure it gets done. They'll never neglect a detail or forget an important task.

Taureans are materialistic and fond of luxury. They're not flashy, but wealth is important because it allows them to have the nicest cars, clothes, wines, and homes. They're fond of beauty and have an eye for fine art and can be talented artists themselves. Their success in the workplace and with investments will ensure that they can afford the finest.

Taurus has the Fixed quality

Taureans are very anxious in unfamiliar situations and when things get out of hand. It's common to see a Taurean try to make everything stay the same, even when it may seem obvious that a change is needed. They demand order and regularity and much of their behavior can be explained by this instinctive need.

Taurus can be stubborn and doesn't like it when someone thinks they know better than them. They are slow to change their mind, if they'll even change it at all. When a Taurean comes to believe something, they stick by it and trust their belief completely. They prefer traditional ways of thinking and are skeptical of new ideas that haven't stood the test of time. Anyone who tries to make big changes must get through Taurus first, who prefers to play it safe and keep doing what they already know works.

Taurus Likes

Taureans like to be known as the person who can be counted on no matter what. They treasure the satisfaction they get from doing things right for others; being meticulous when so many rush through tasks. Taking care of every detail in their work (and play) is a joy for Taurus. They like to be wealthy enough to provide for others and help them when they're in need. Taureans know they are the opposite of flaky and they love it when others realize just how honest and dependable they truly are.

Taureans love luxury. They like money a lot and will sometimes hoard it; they like to see large numbers in their bank balance. But once they have enough, they will be sure to buy all the finest things. Taureans can seem like showoffs, but really, they just like to feel successful and be surrounded by beautiful things. Taureans are fond of gold and silver jewelry. The newest cars and clothes are a must have for Taurus. Taureans don't just want to keep up with the Joneses, they want to blow them out of the water.

Taureans enjoy stability and living in a predictable routine. They want to know what's coming next at all times. They like it when other people keep their promises and can be counted on, because Taureans will always do this for others. Taureans love to have

financial stability, and being rich makes them very happy, and moving towards this goal, then maintaining it, is a great joy for them.

Taurus Dislikes

Taureans hate instability. Unpredictable and impulsive people make them uncomfortable and resentful. Taureans have little patience with anyone who acts without considering the consequences. They don't like to be forced into making a decision on the fly, they need time to weigh and consider all options. Irresponsible behavior, like not working hard and mooching off others can really trigger Taurus. Anyone with a disregard for safety is unlikely to be trusted by a Taurean.

Big changes in a Taurean's life make them feel anxious and out of balance. When they find themselves out of work they will scramble to find a new job, for fear of losing their comfortable and stable life. A Taurean can't stand not having nice things. New surroundings and new people are only welcome when they are introduced in a slow and controlled manner; being thrust into new places and social groups can make a Taurean unhappy.

Taureans do not like changing their minds. When someone disagrees with them, Taurus may simply disregard their arguments. They are stubborn and hate being told they're wrong. If one tells a Taurean to do something they don't think is a good idea, the Taurean will ignore them, which can be interpreted as laziness. If their core beliefs are seriously challenged, Taurus may become angry, or just avoid the situation altogether. They tend to have very conservative political views, and when radical ideas are discussed Taurus may think of them as crazy or dangerous.

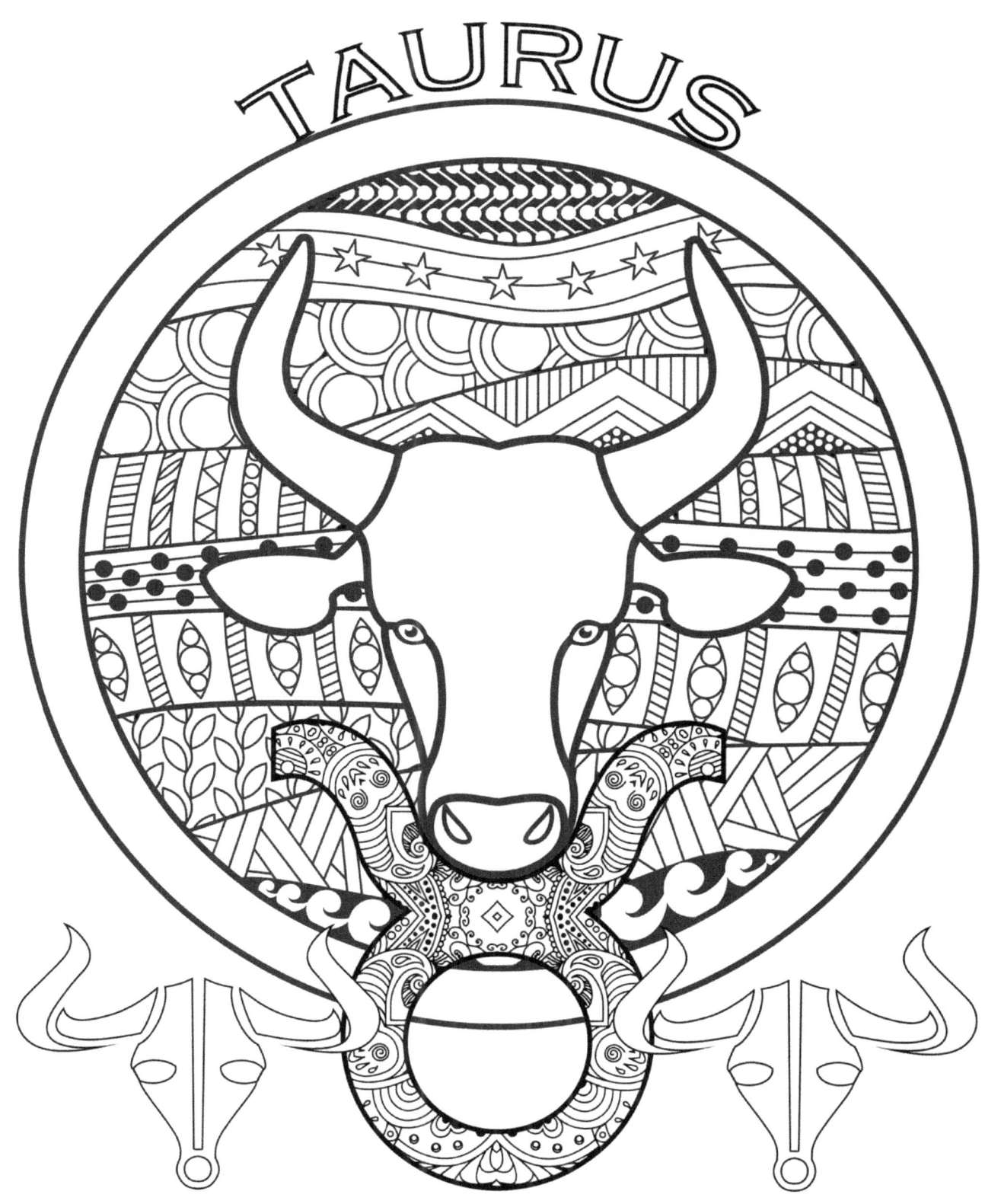

Taurus people enjoy sitting and the outdoors, so an outdoor café can be a favorite place.

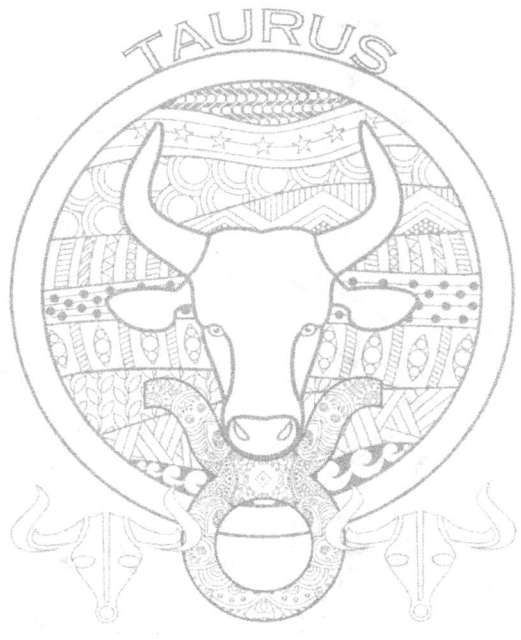

Taurus likes things that feel great and mellow animals make the perfect pet for them. So a cat that can enliven Taurus' tactile sensitivity will do wonders for them.

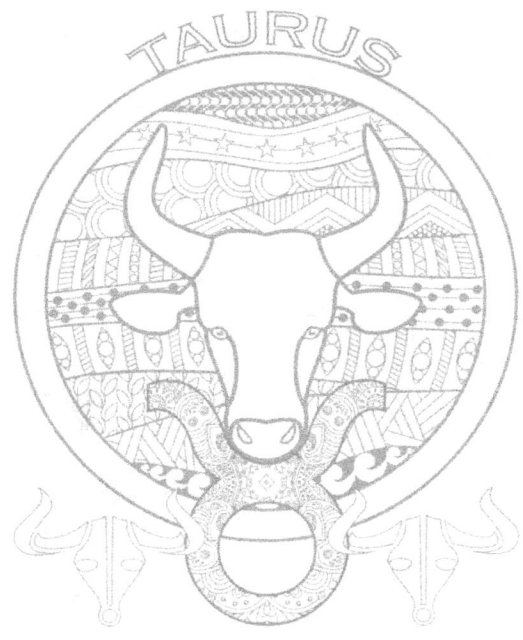

The favorite environment of a Taurean is a quiet place.

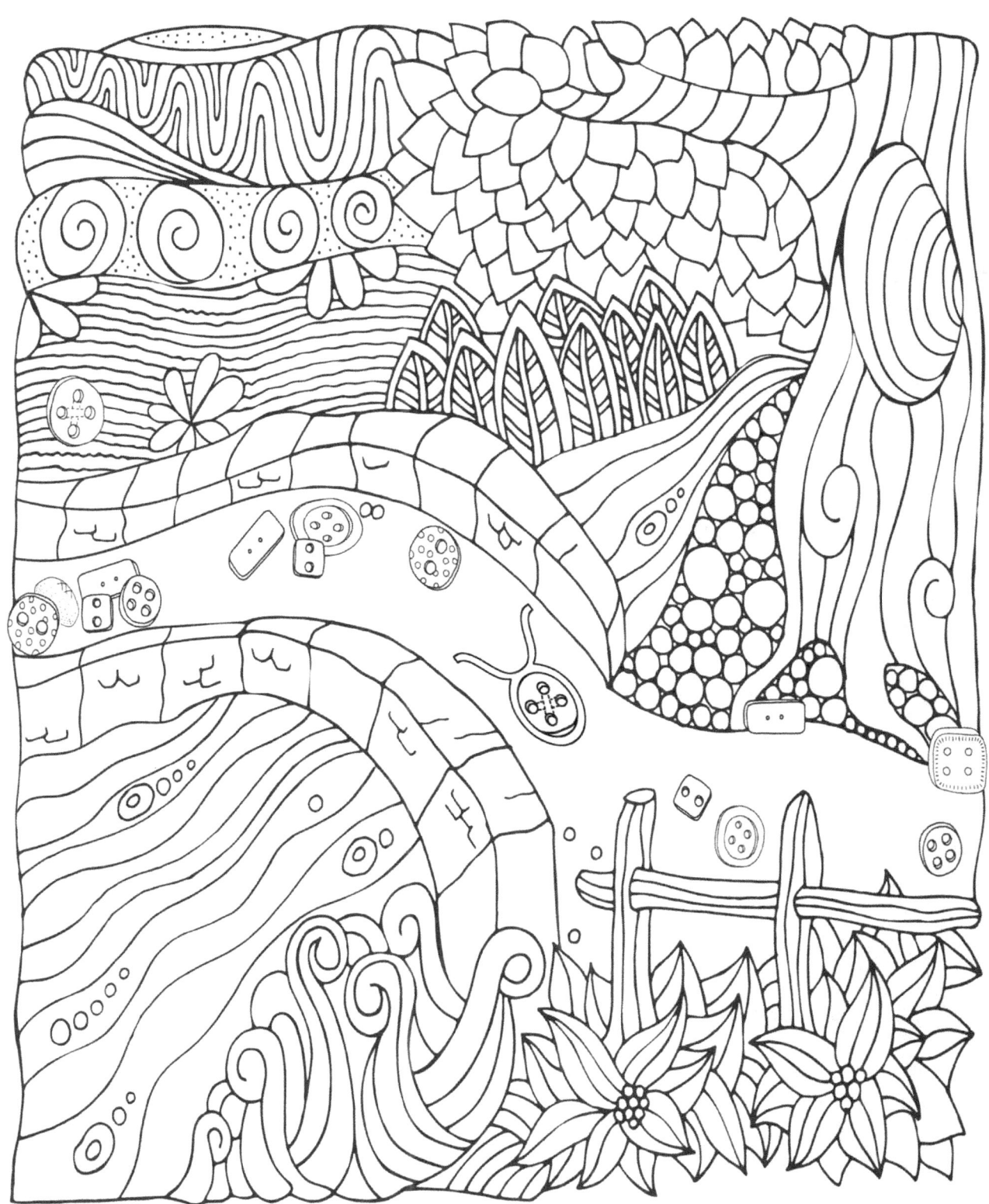

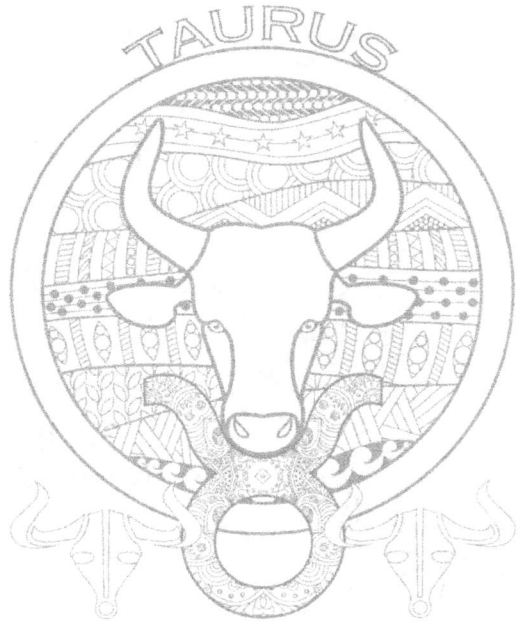

The Earth is the element of Taurus.

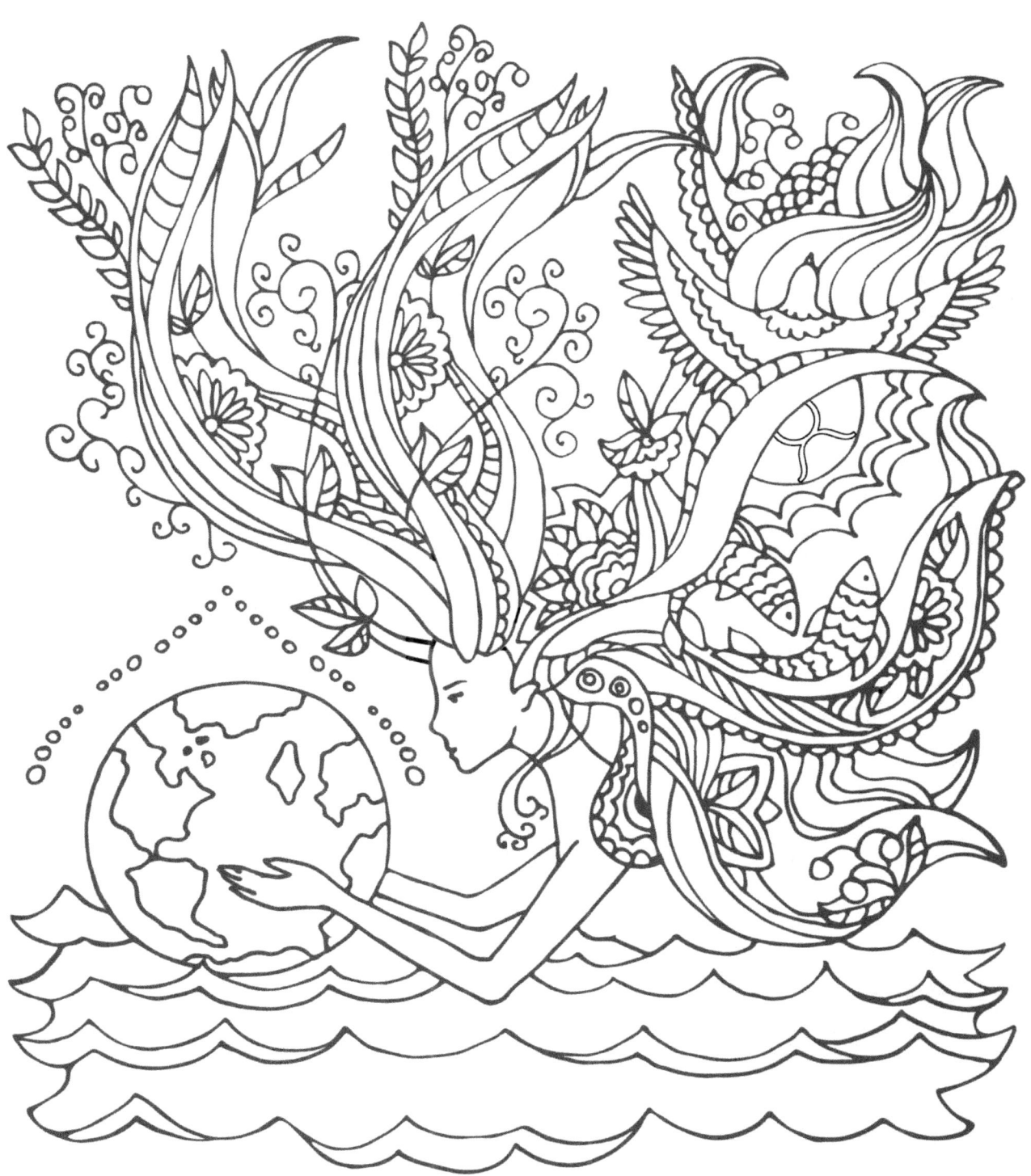

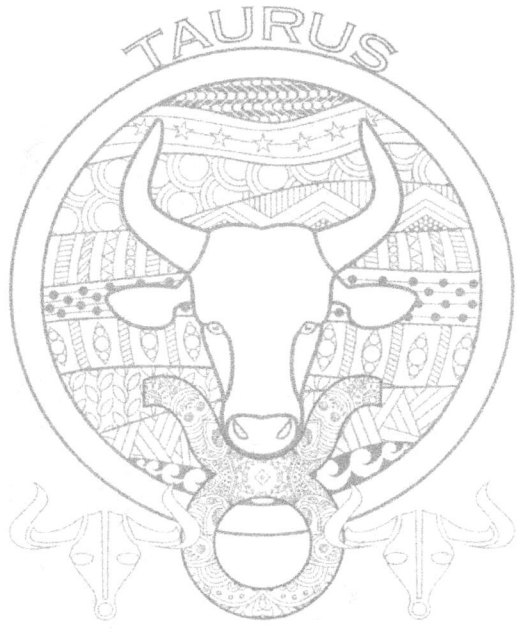

Taureans often enjoy knitting or knitted-wear.

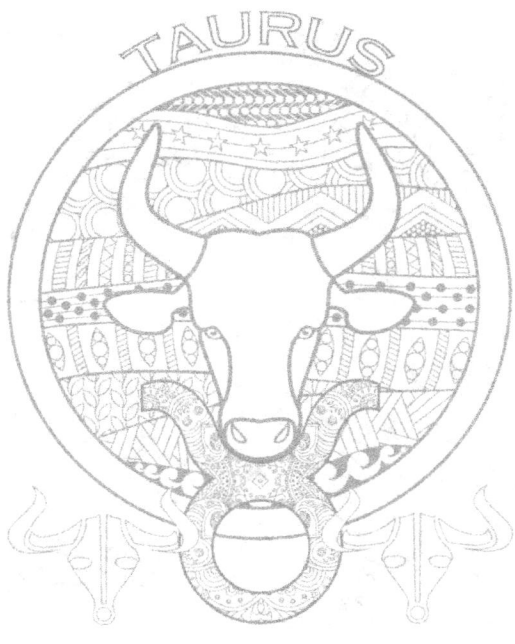

A comfy couch is a great place for Taurus people since they enjoy sitting.

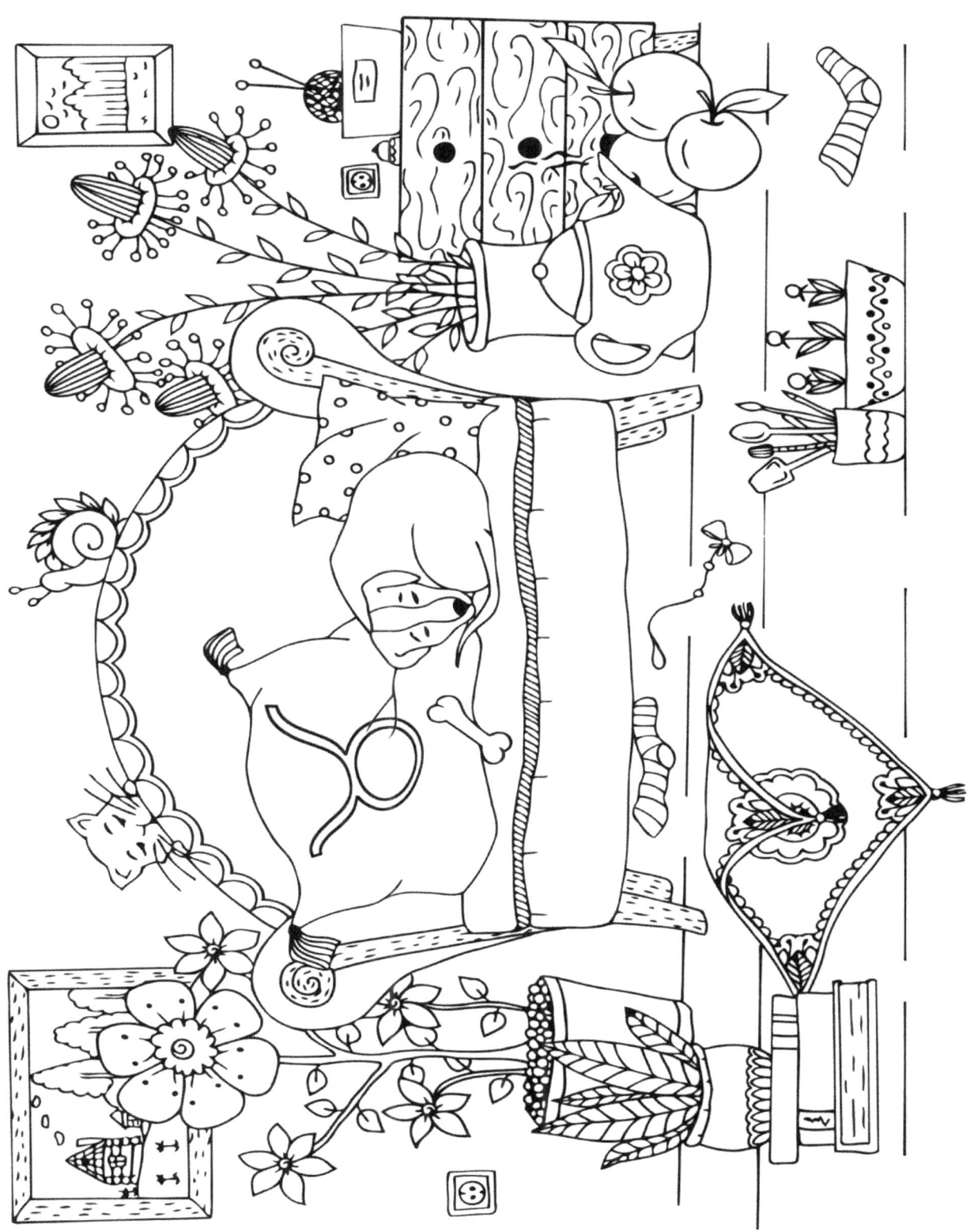

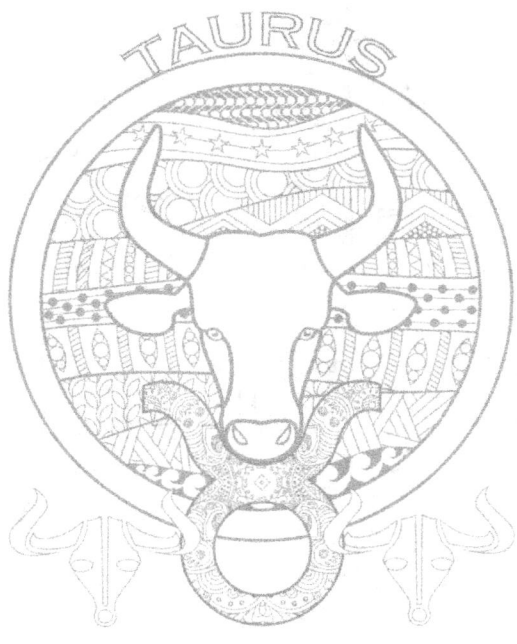

Taurus people like the finer things in life including gold and silver jewelry.

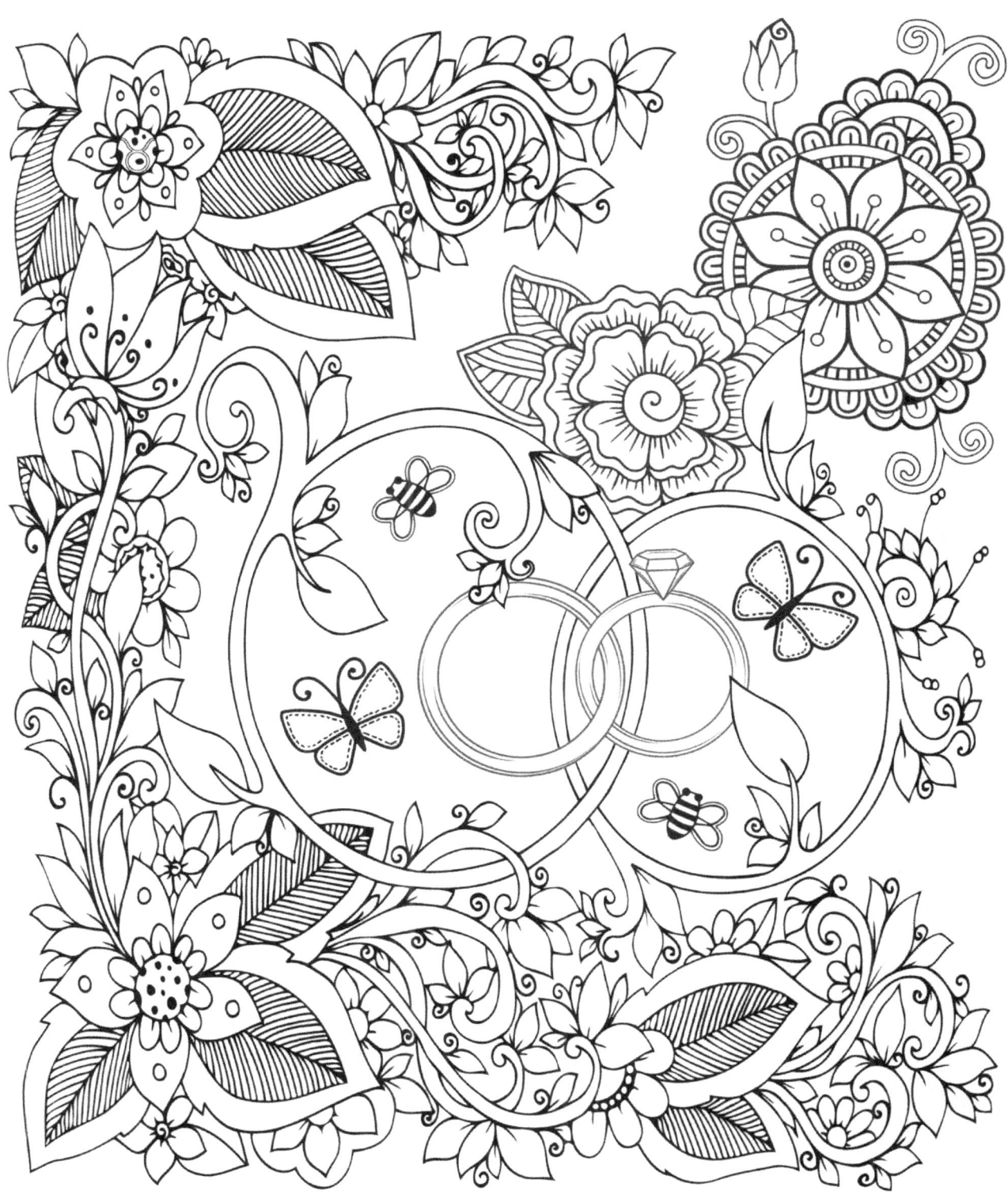

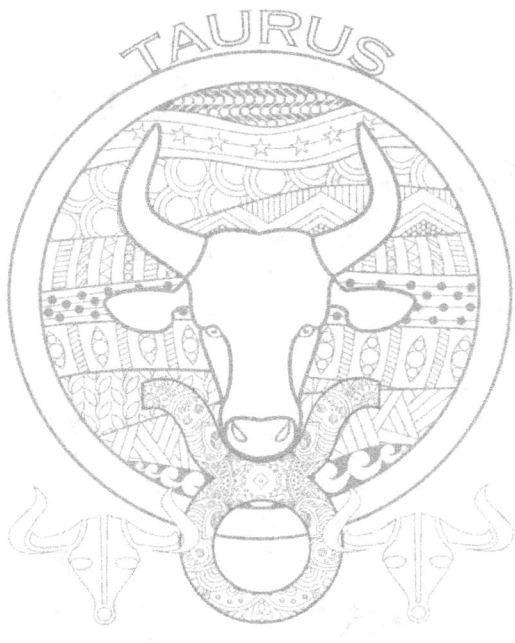

Being an Earth sign ruled by Venus gives Tauruses an affinity for sensuality.

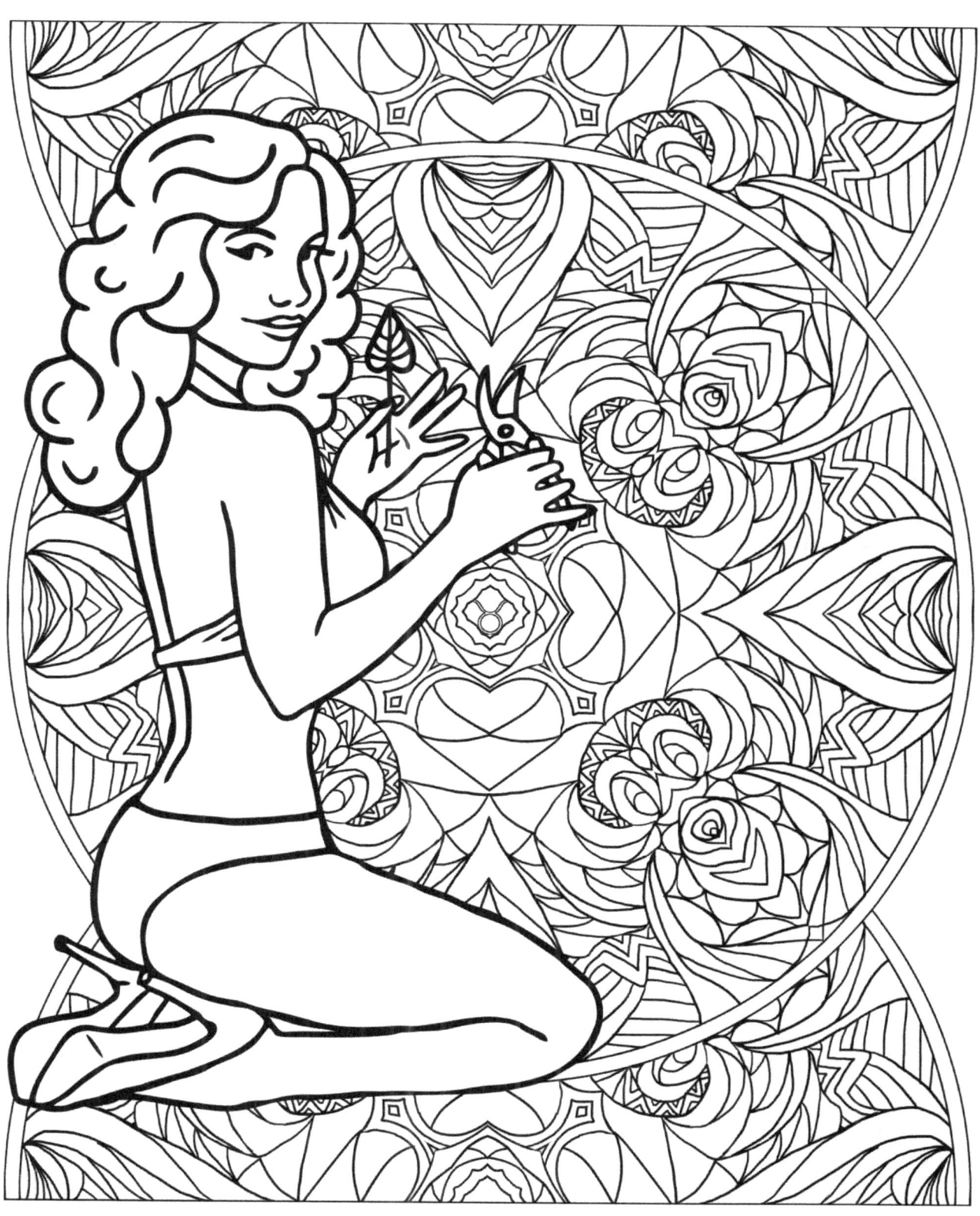

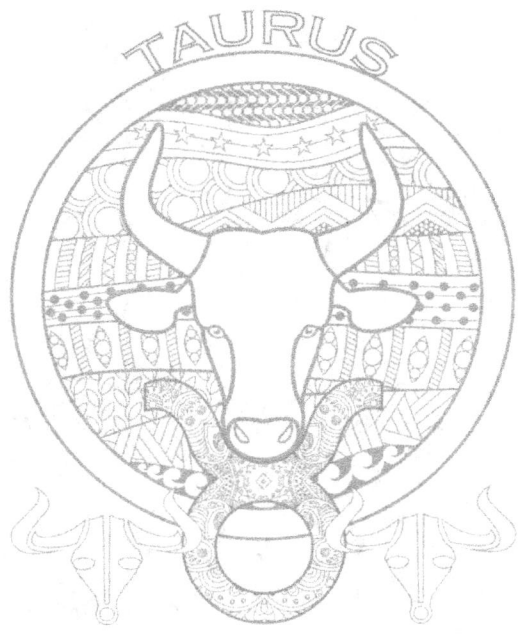

The palm tree represents that sense of reward and pleasure that Taurus loves.

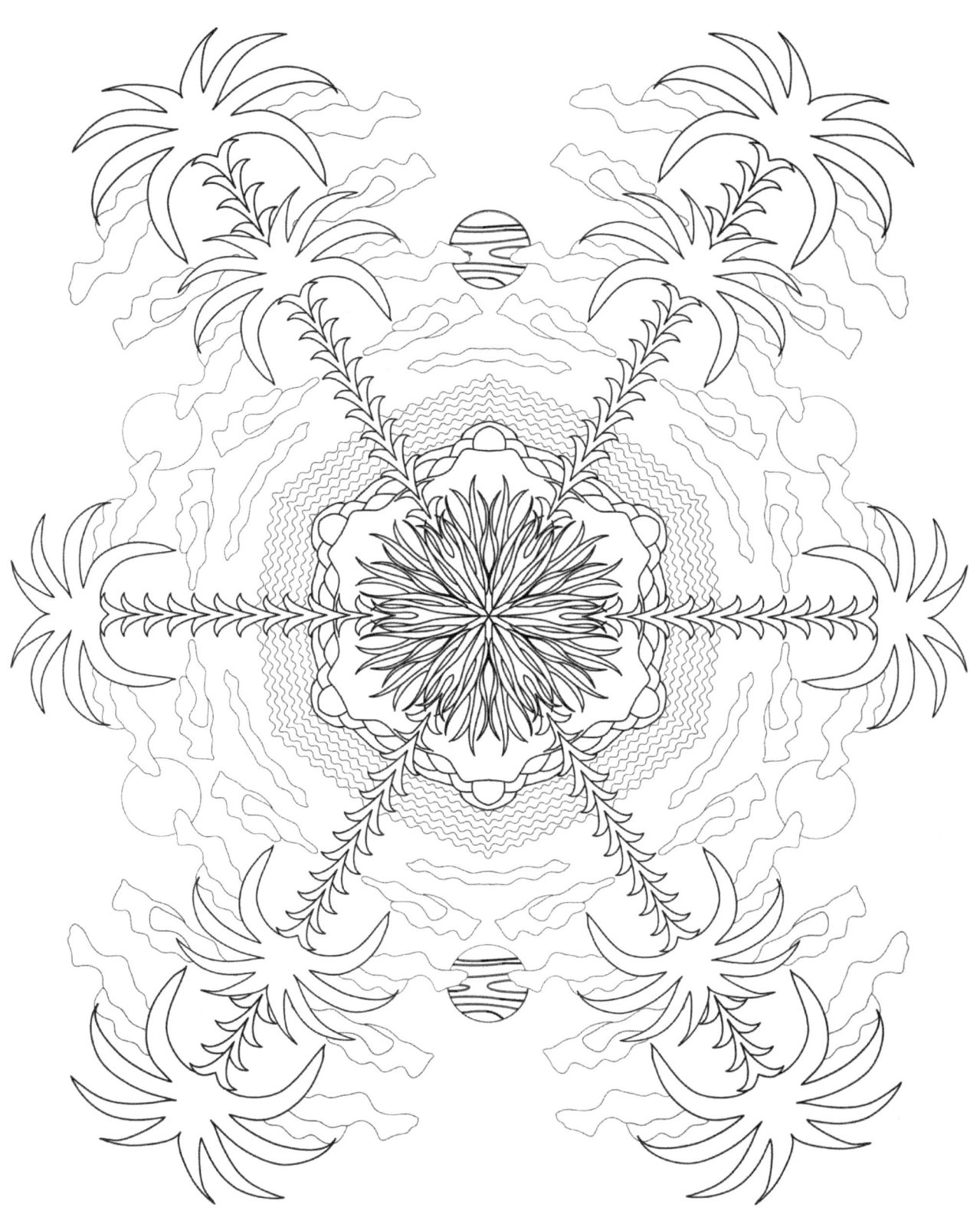

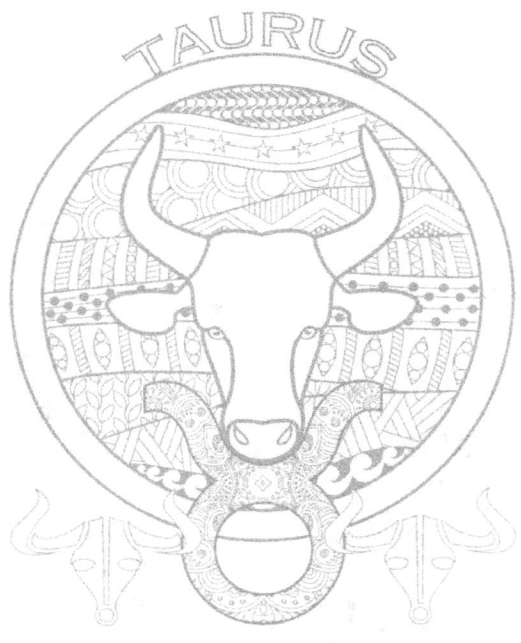

Being down to earth but with a taste for finer things, Taurus can be happy with a nearby park rather than living way out in the country.

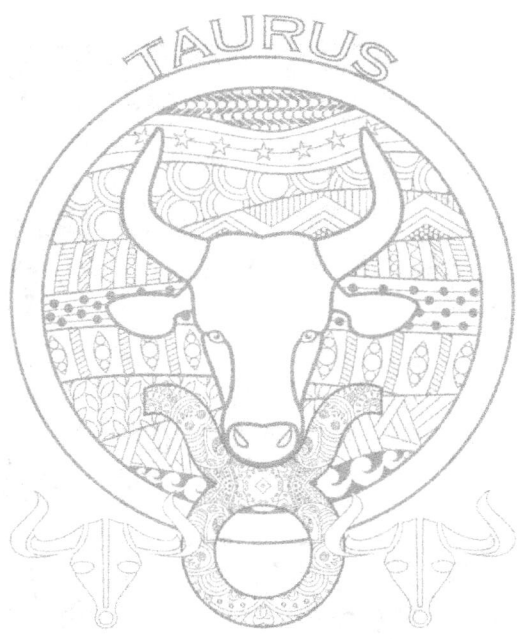

Tasting wine, eating delicious food, and enjoying the environment around them will appeal to every sensual side of the Taurus.

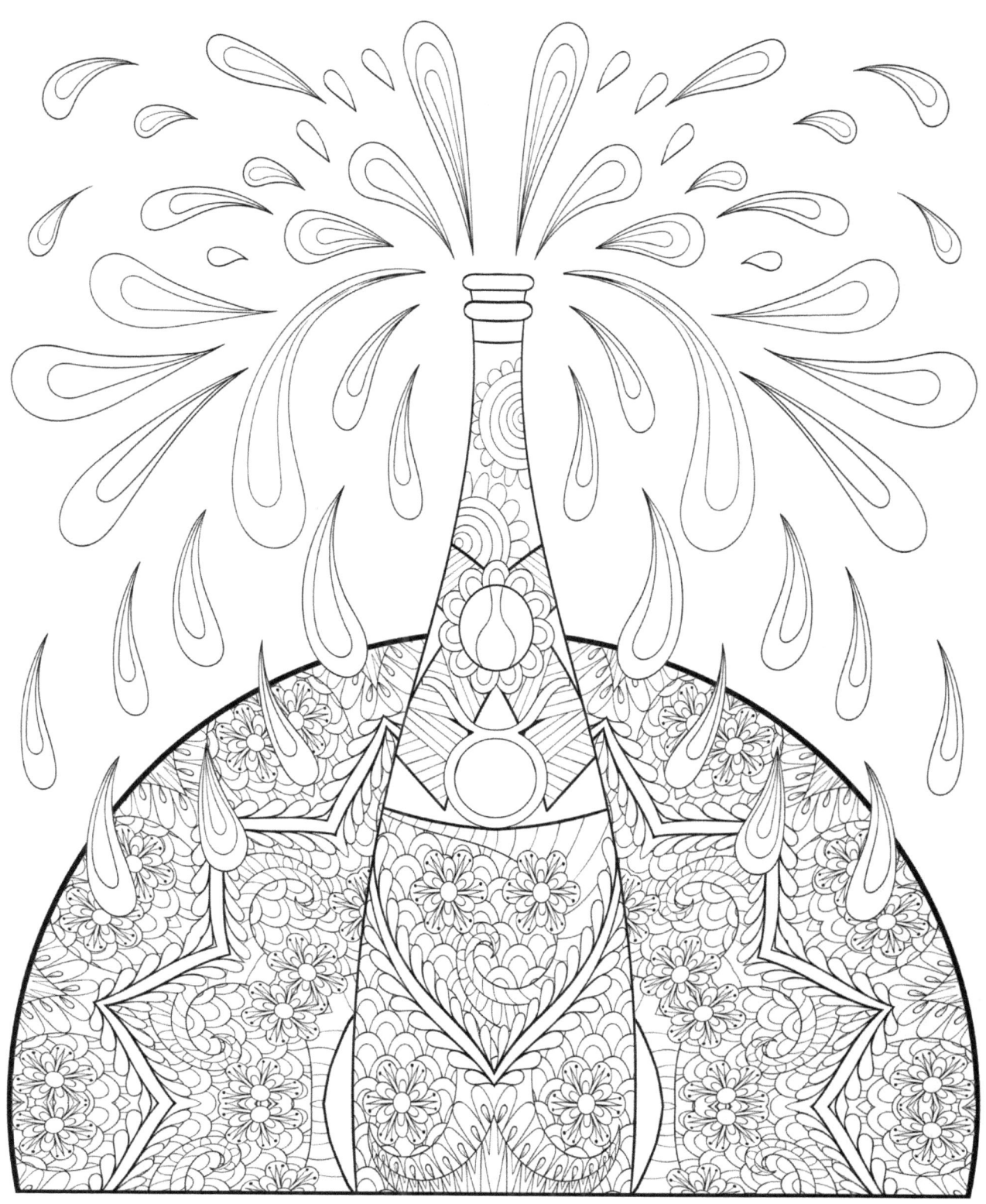

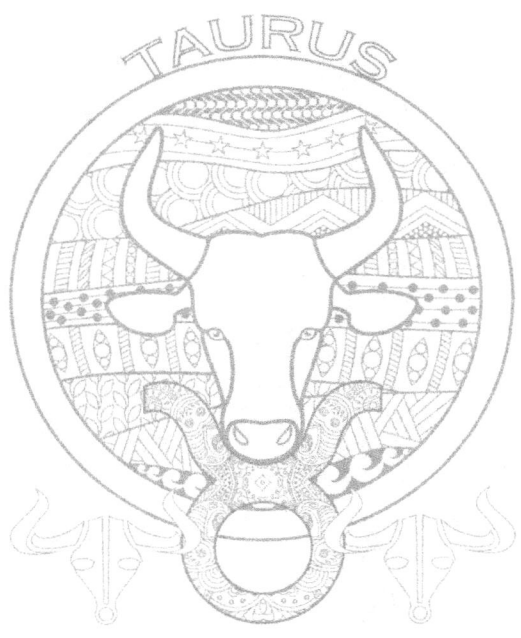

Taurus people prefer to sit so if a place doesn't have somewhere comfortable to sit they won't enjoy being there.

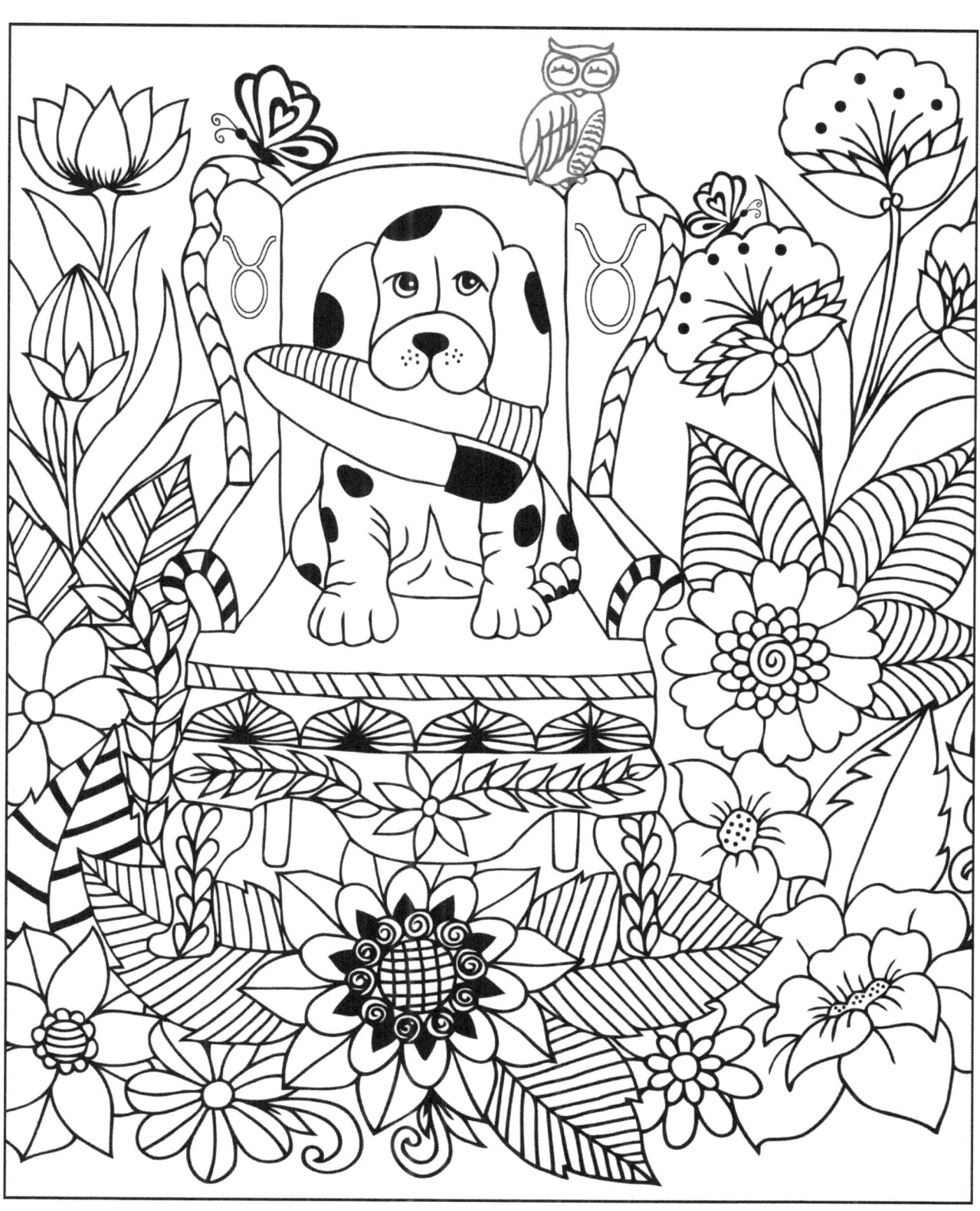

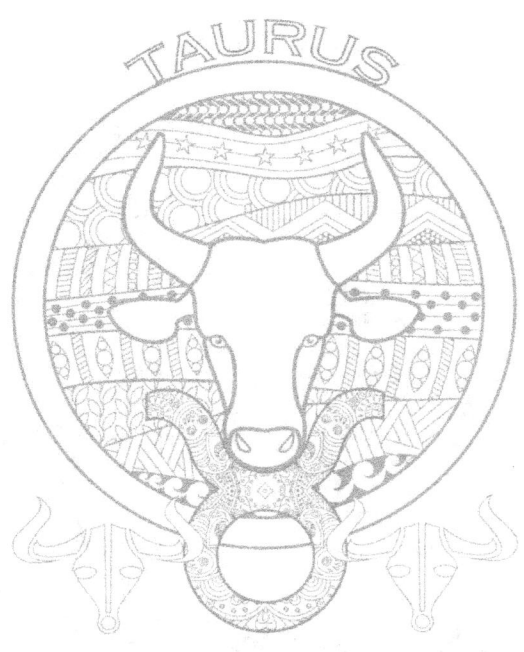

A princess blessed with luxury grounded by the earth is a wonderful representation of Taurus.

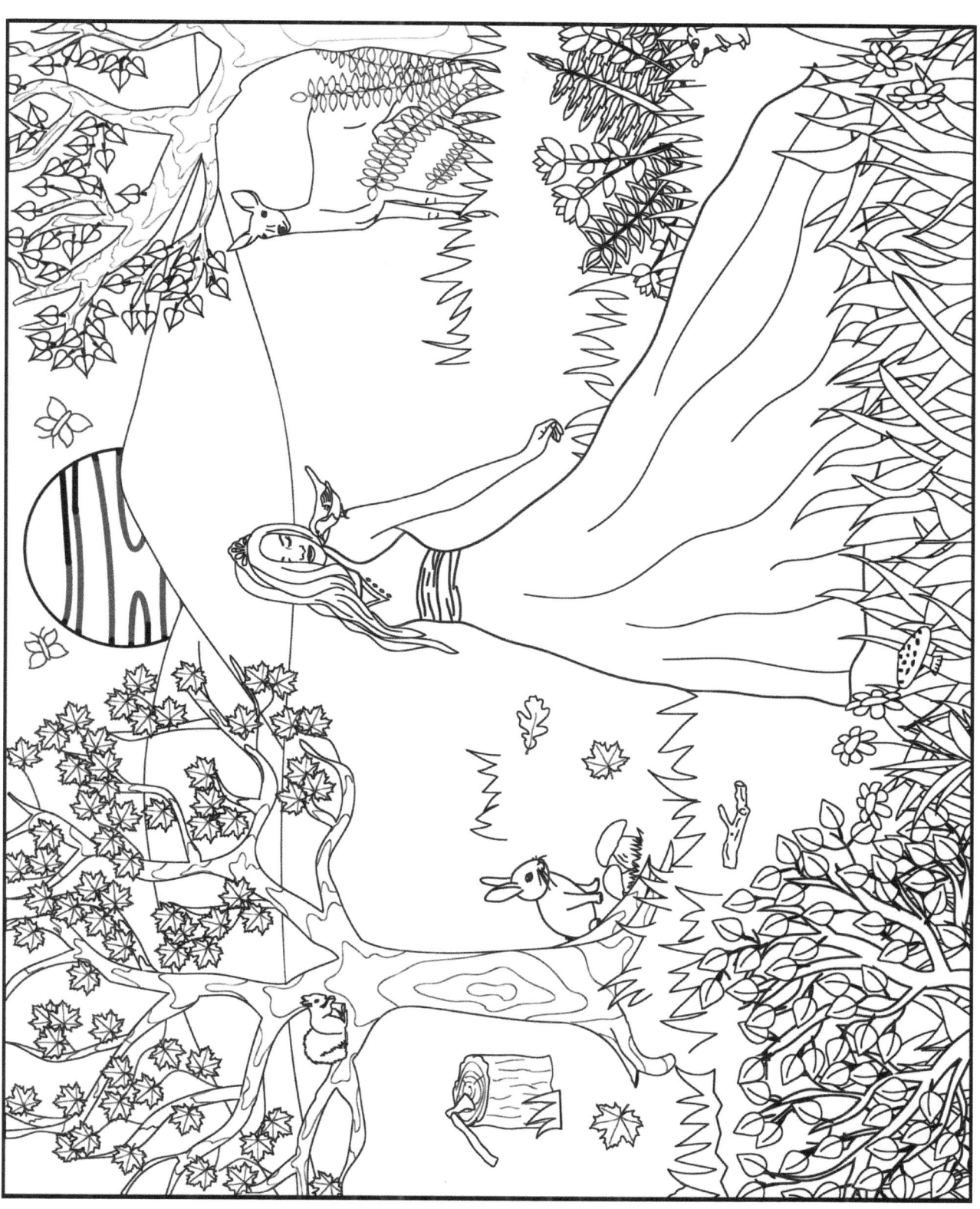

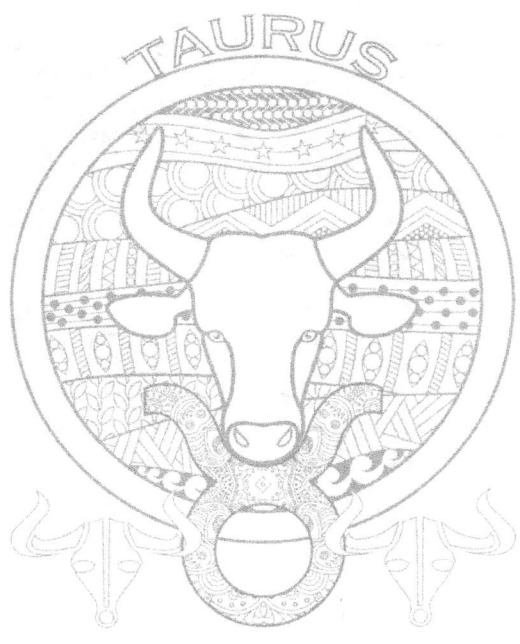

Taurus rules the throat and neck so Taureans tend to be good singers and enjoy being in a choir or band.

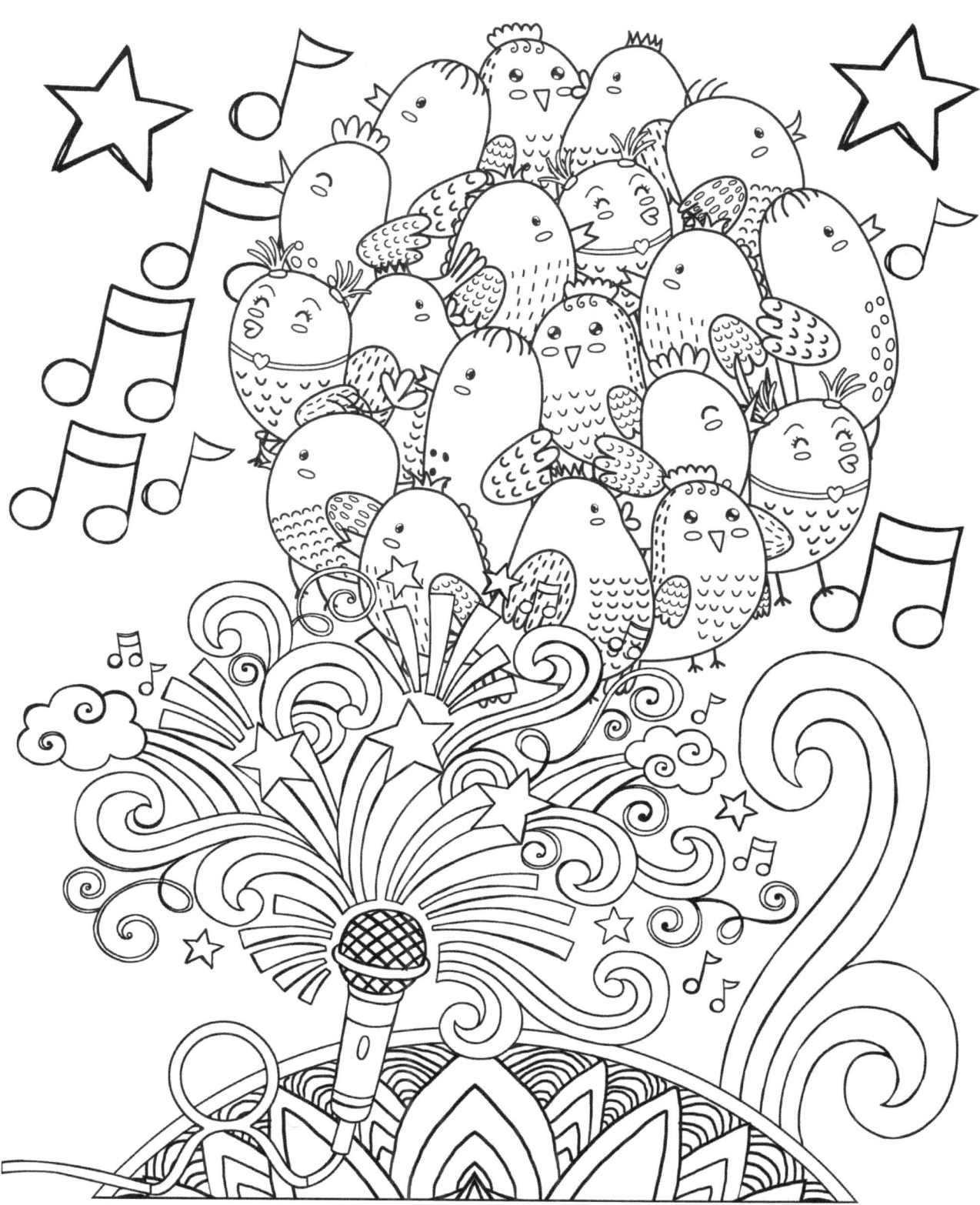

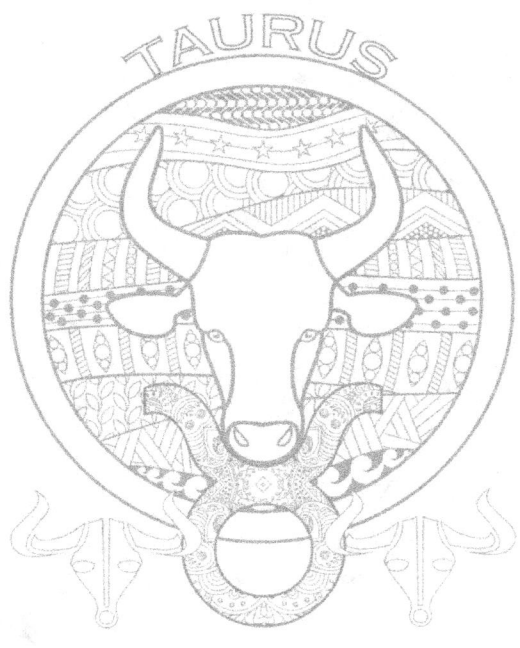

Taurus Mandala - Venus, Earth, Palm, Symbol, Rose

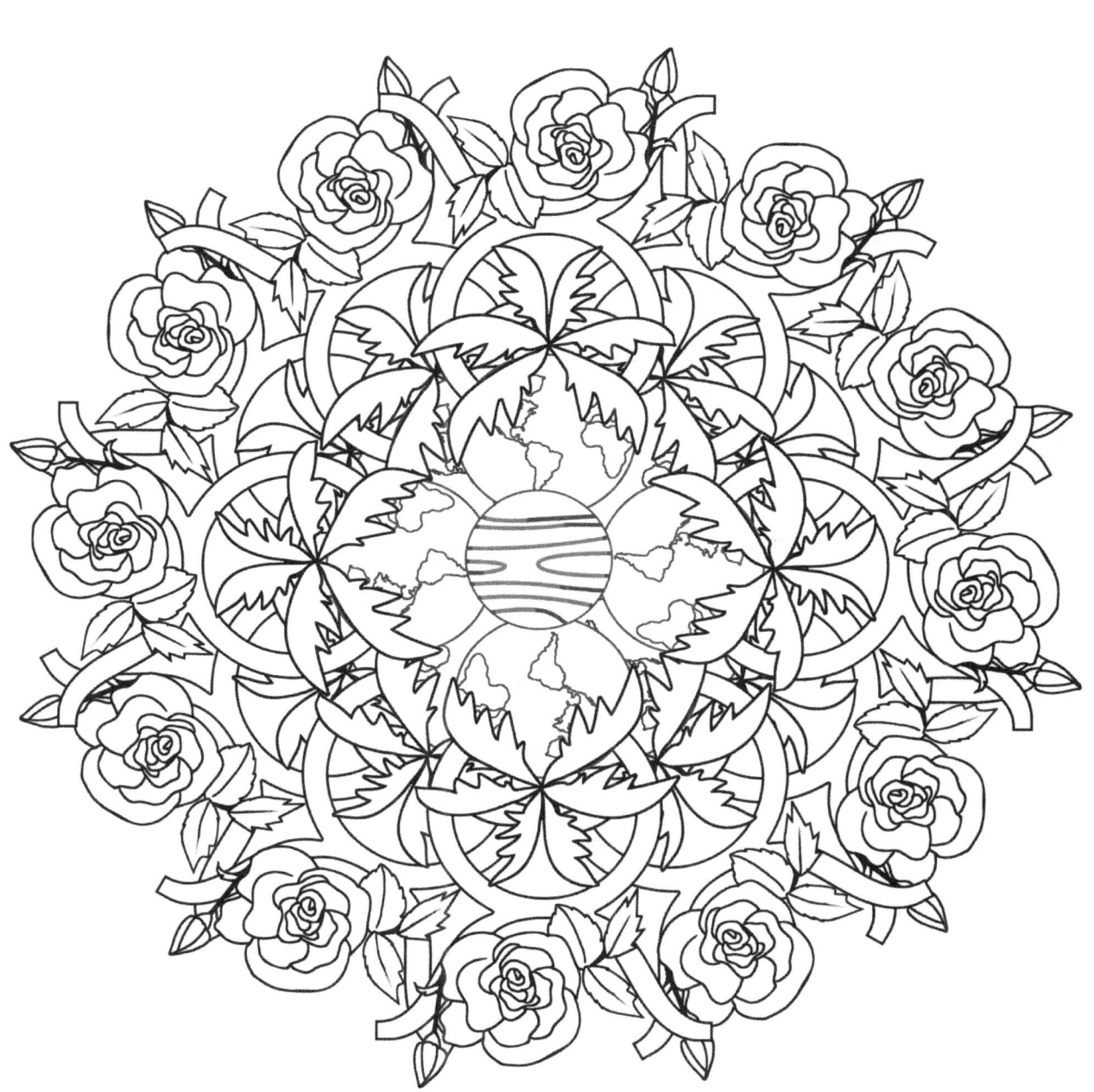

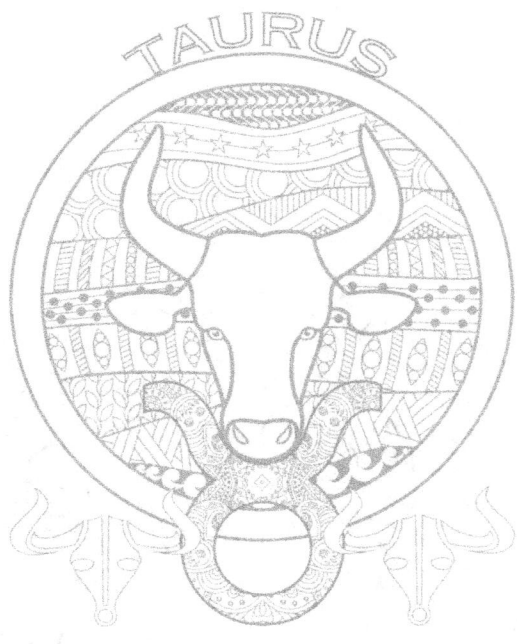

A soft, snuggly kitty who imparts a sense of love and whose purring body vibrates from caresses matches well with the tactile, comfort-seeking Taurus.

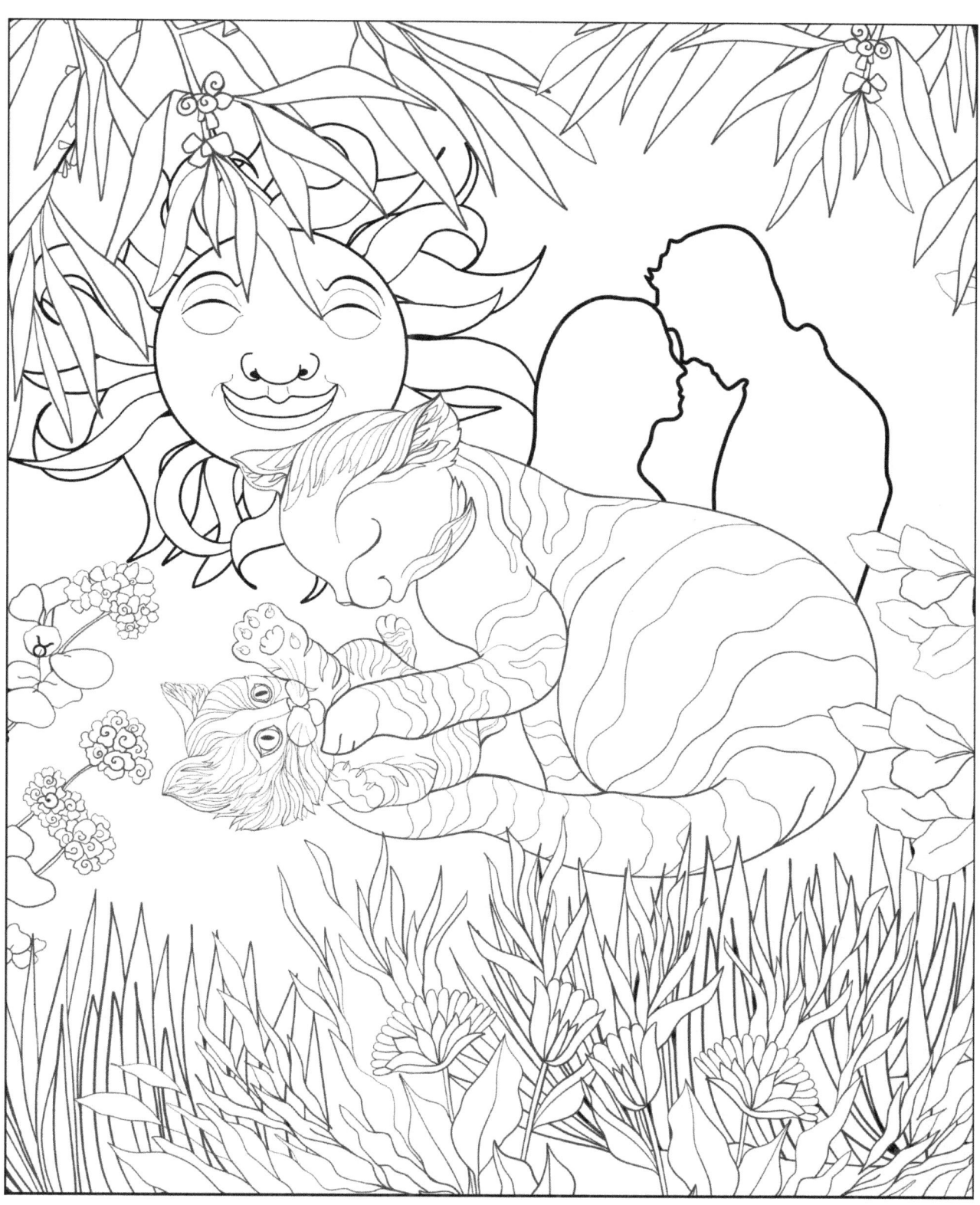

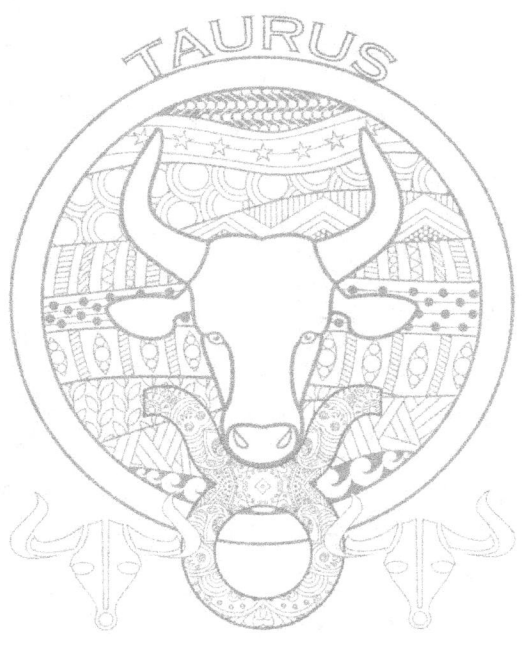

Taurus people prefer activities which are slow or those which can be performed sitting in a place so chess can be a good game for them.

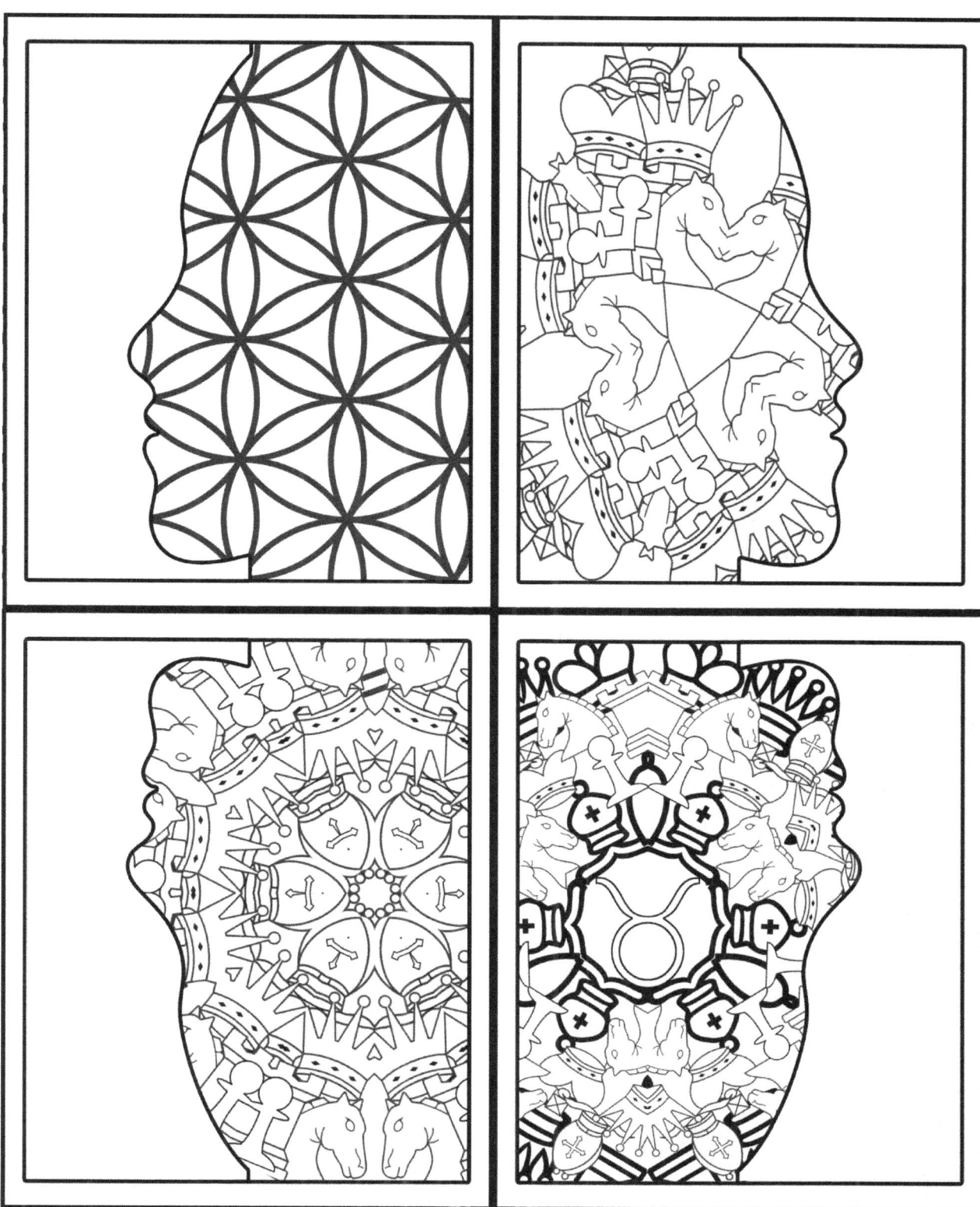

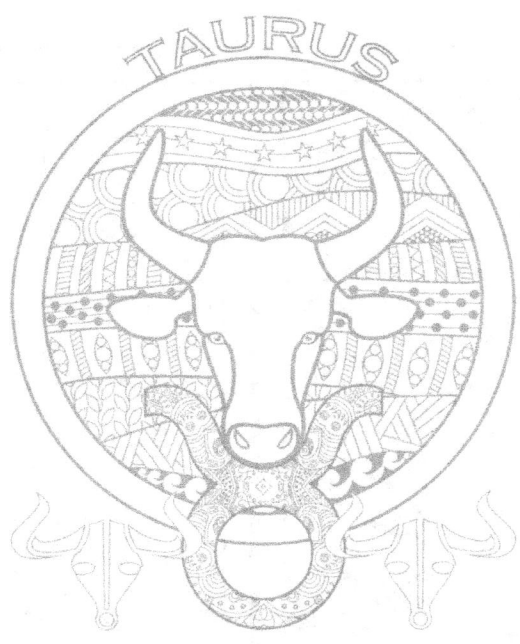

Taurus' best pet is a true and constant companion and an intelligent, loyal dog like a shepherd is a good choice.

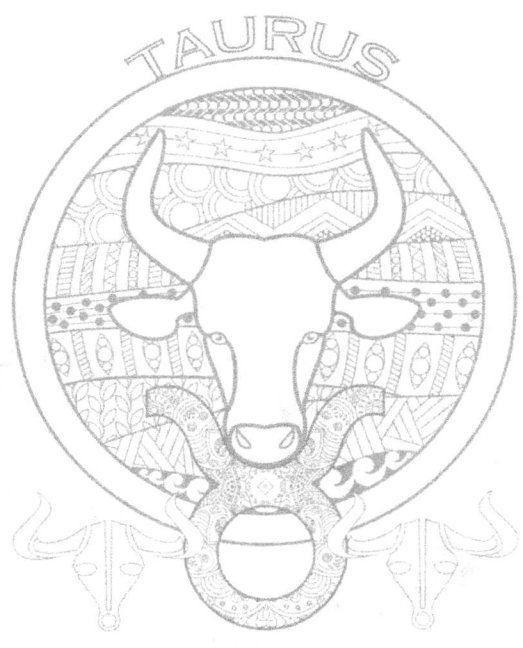

Citrus aromas are very uplifting, but lemon in particular is often associated with cleanliness and good health which suit the Taurus well.

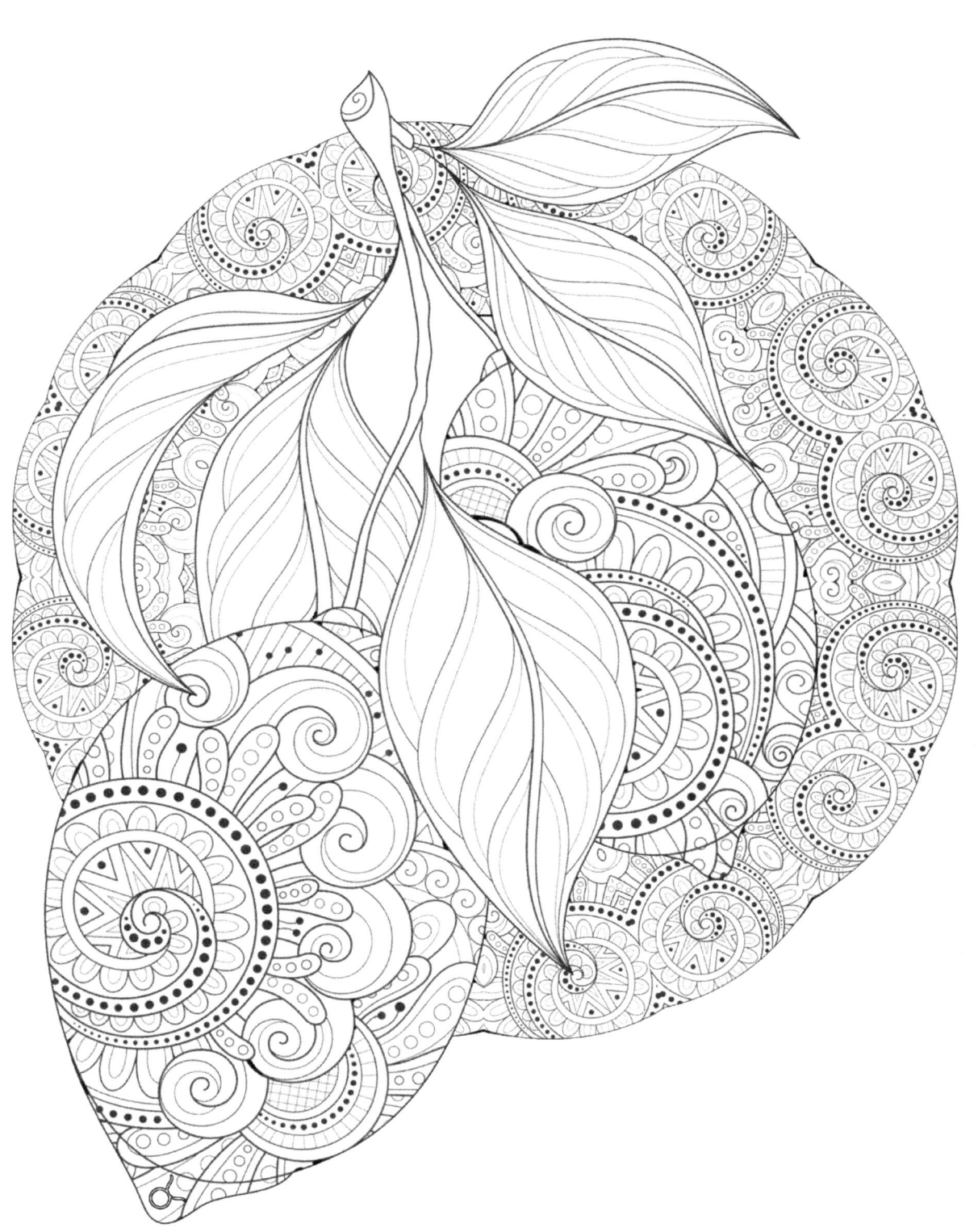

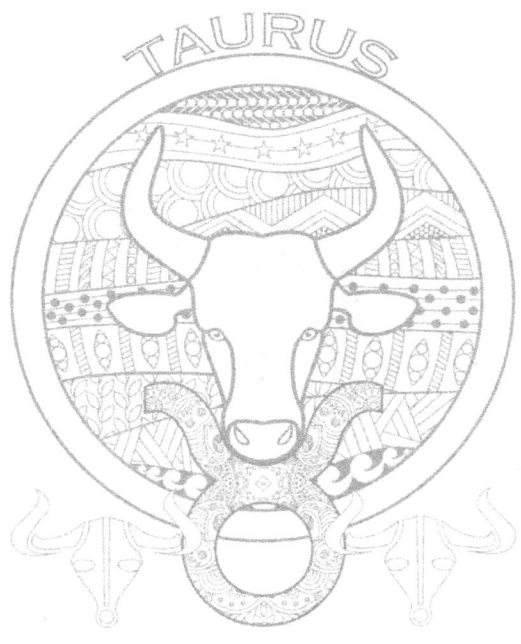

Taurus are very rooted people, as they are a Fixed, Earth sign.

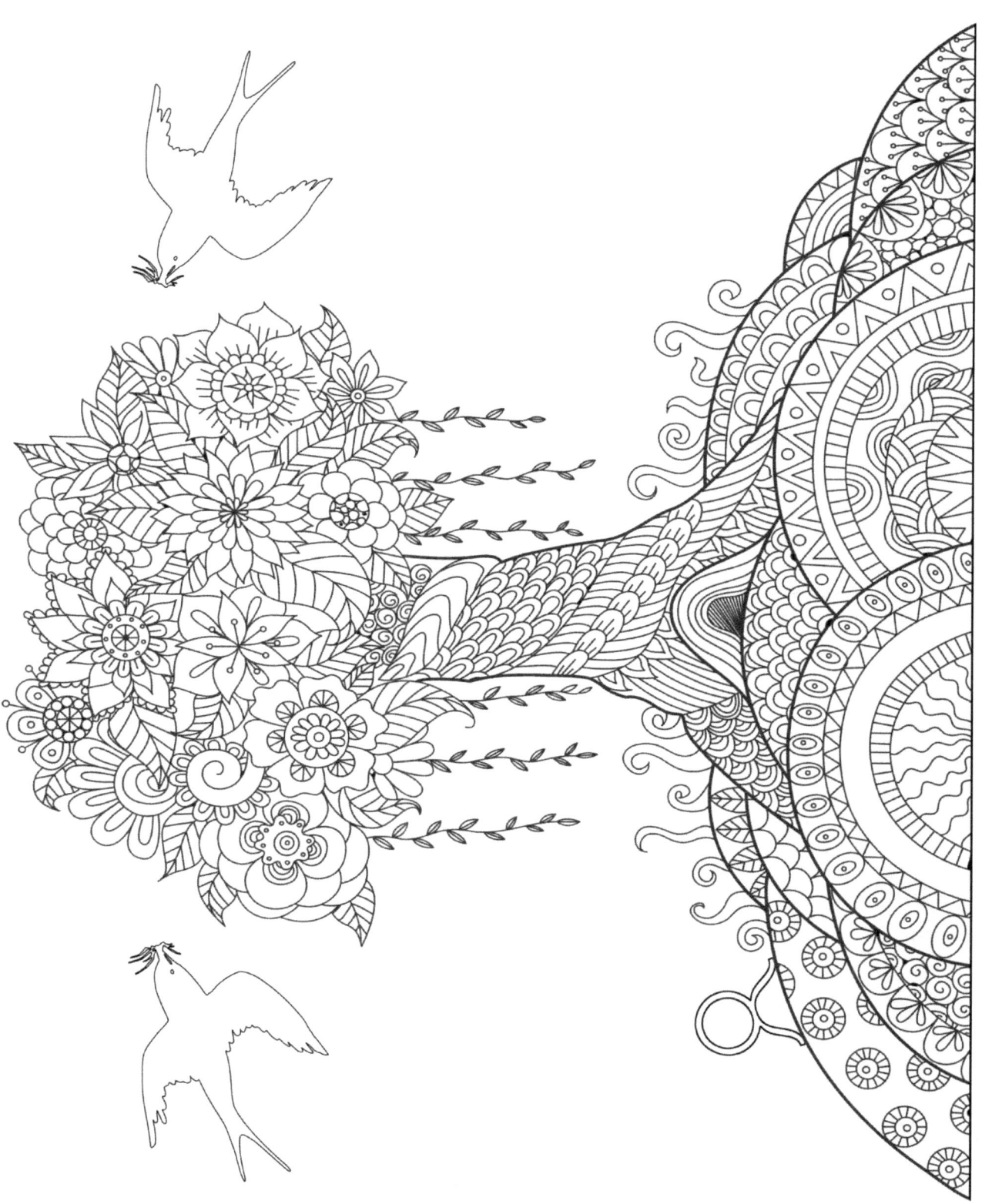

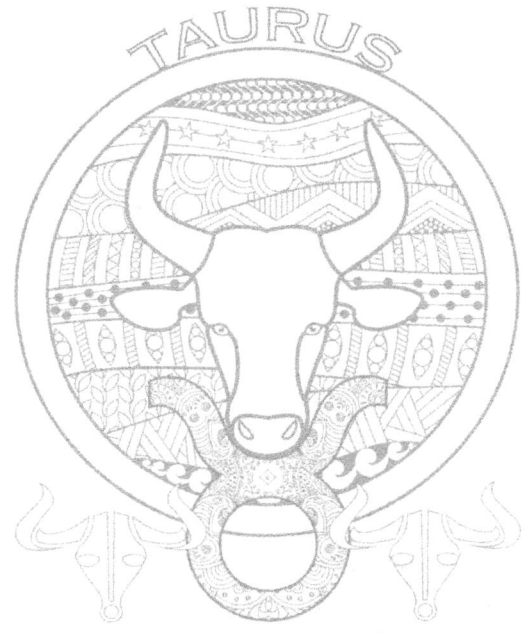

The symbolic meaning of poppy is linked with exploration of the senses. This fits wonderfully with Taurus' desire and ability to get intimately tactile with their environment.

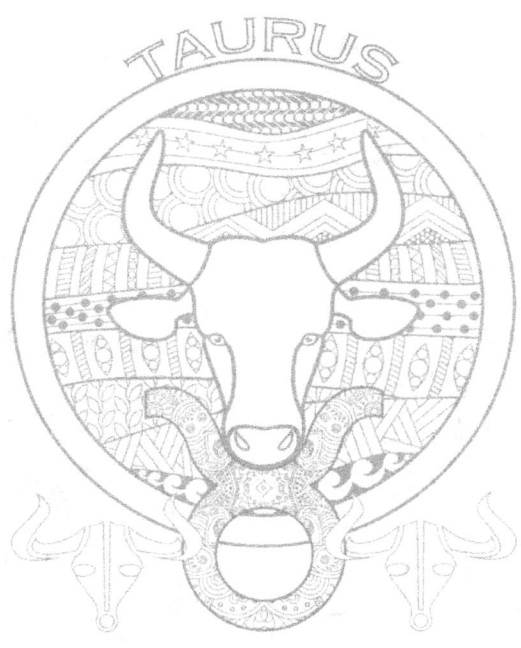

Like a bull grazing in a field, Taureans love peace and do not like to be disturbed.

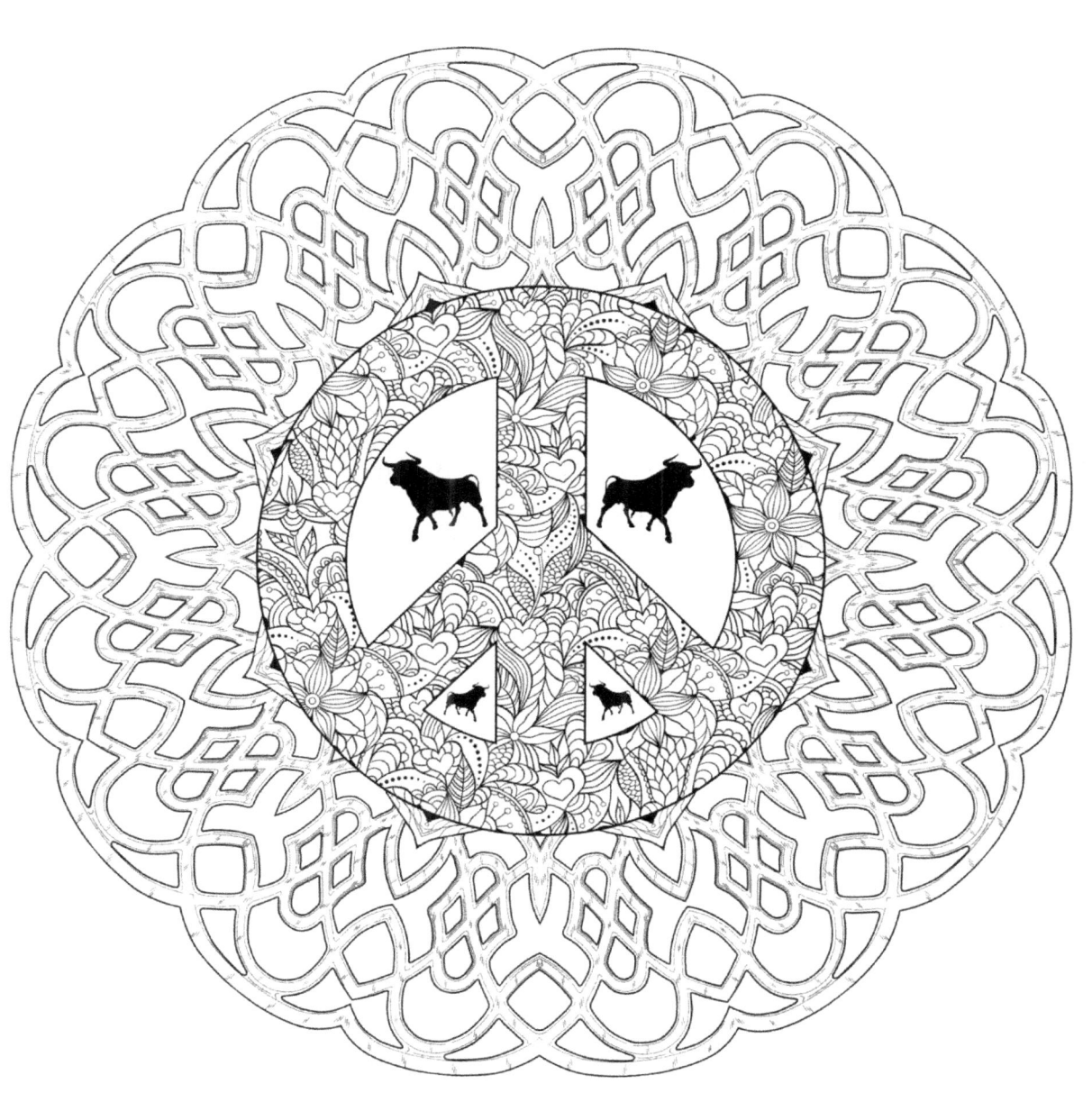

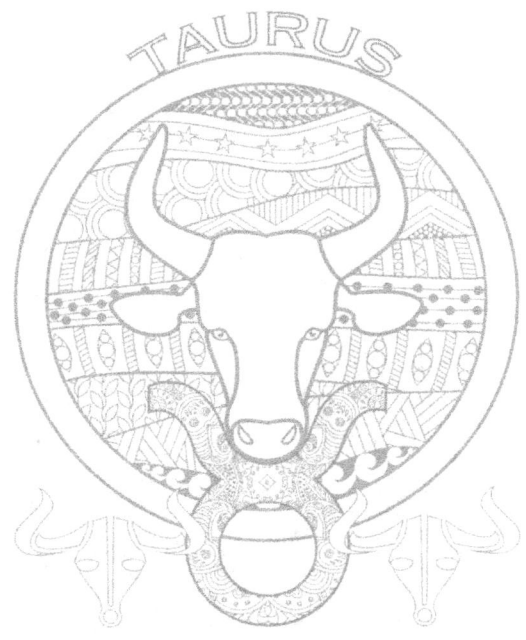

Taurus has the qualities to be the best gardener in the zodiac but not always the motivation. The best garden for Taurus has plants that touch multiple senses, like plants with strong and pleasant fragrances. Make sure to have a comfy place to sit for lounging outside.

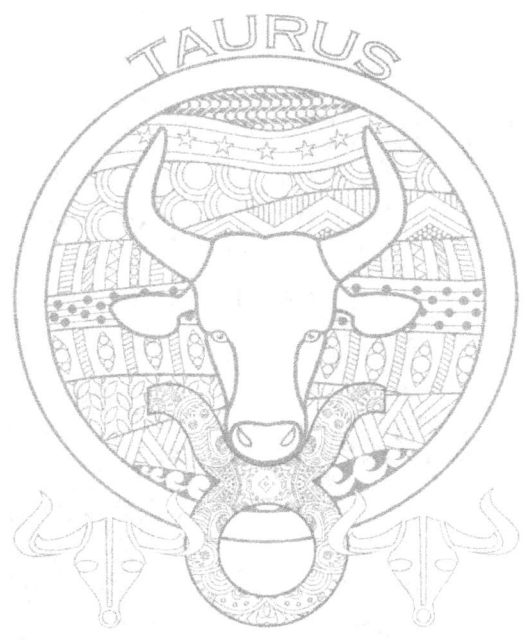

With their slow pace, quiet nature, slight attitude, stubbornness and shell that is like a Taurus' reliable outer strength, a turtle cam make a good pet.

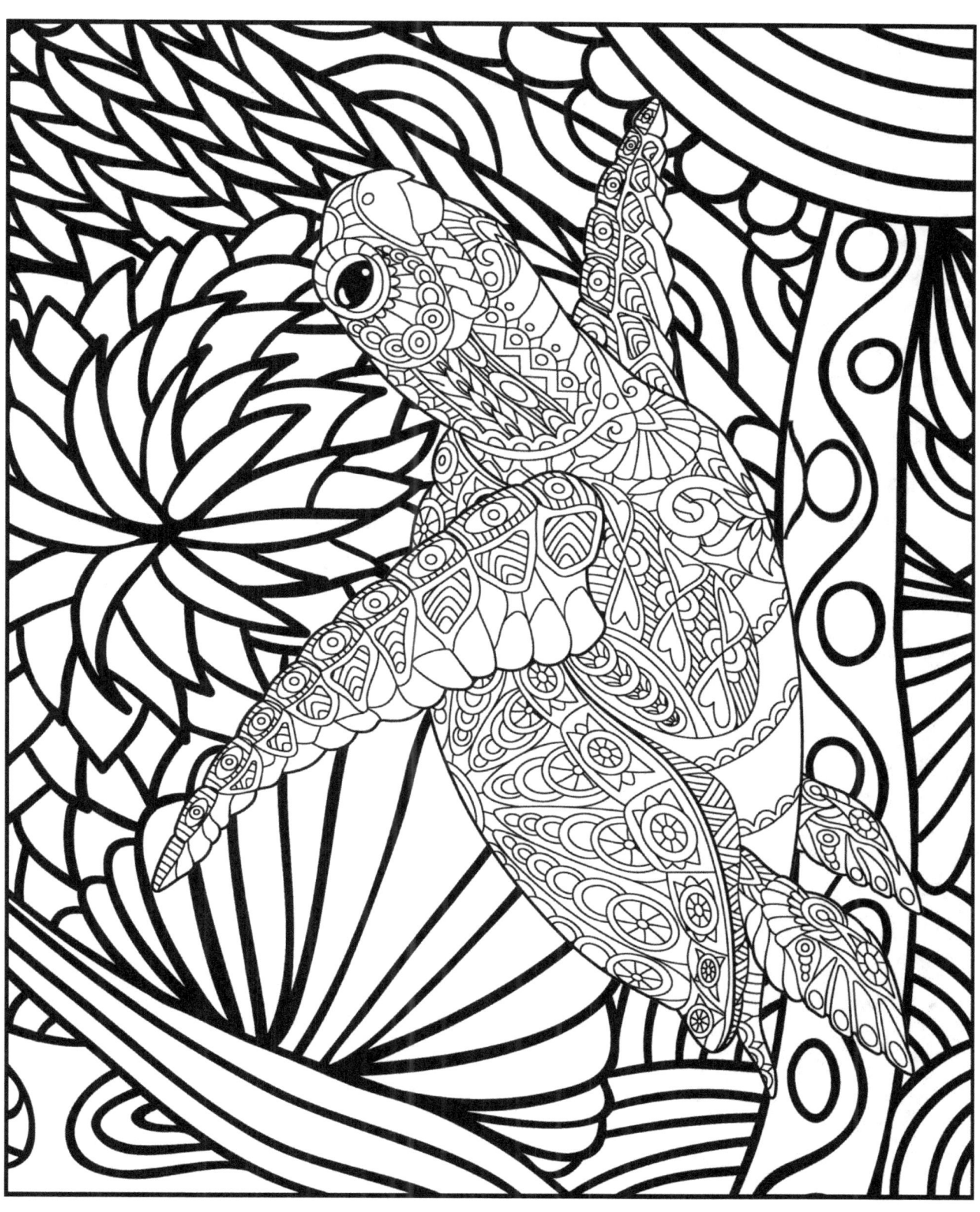

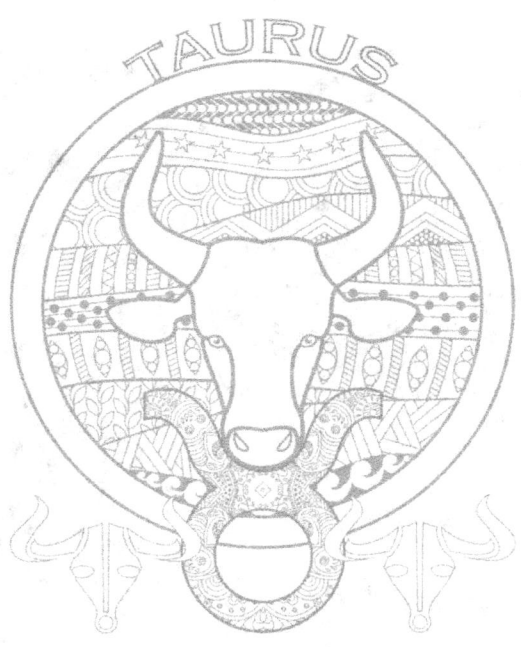

Ruled by Venus, Roses are closely tied to Taurus and are one of their birth flowers.

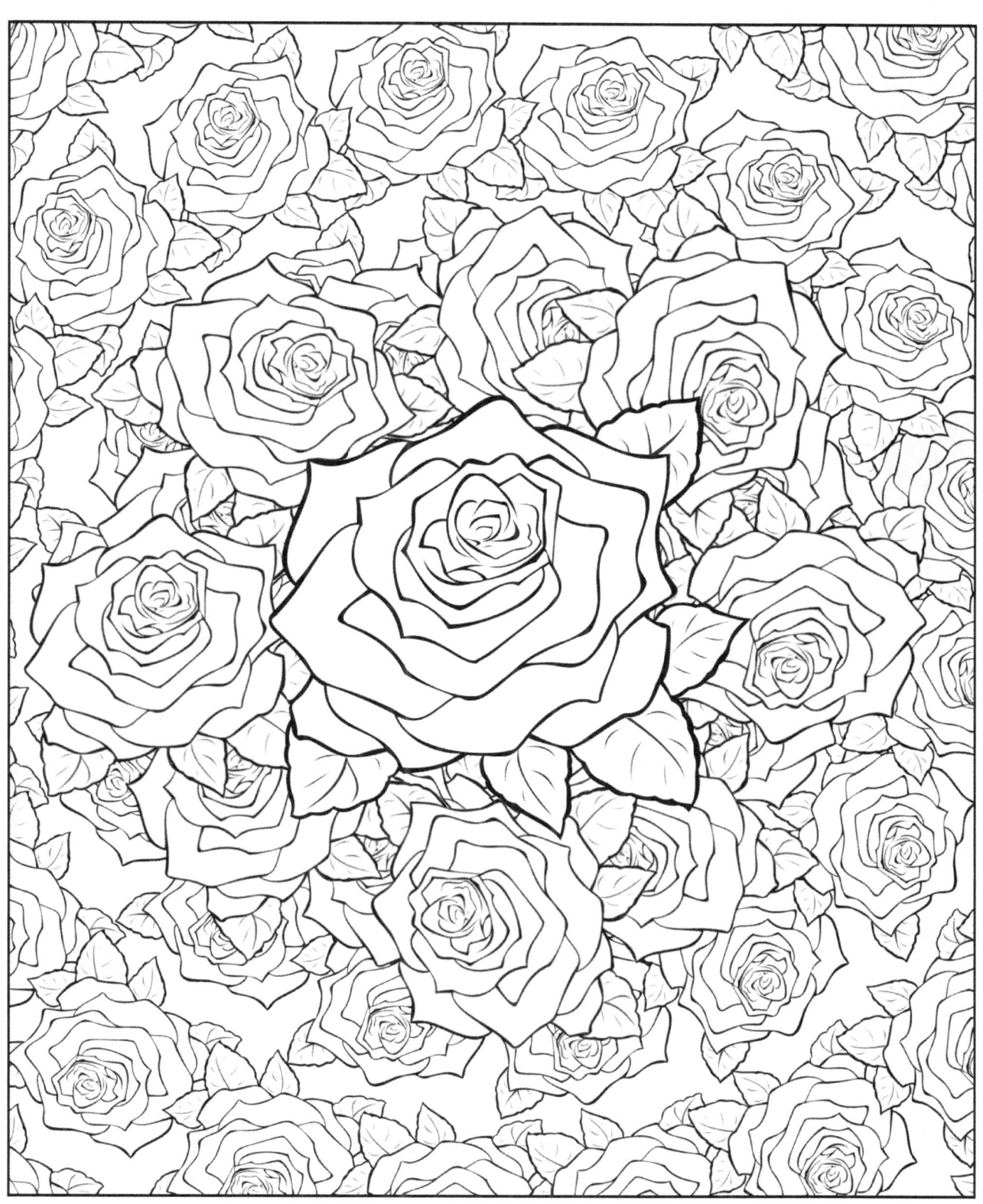

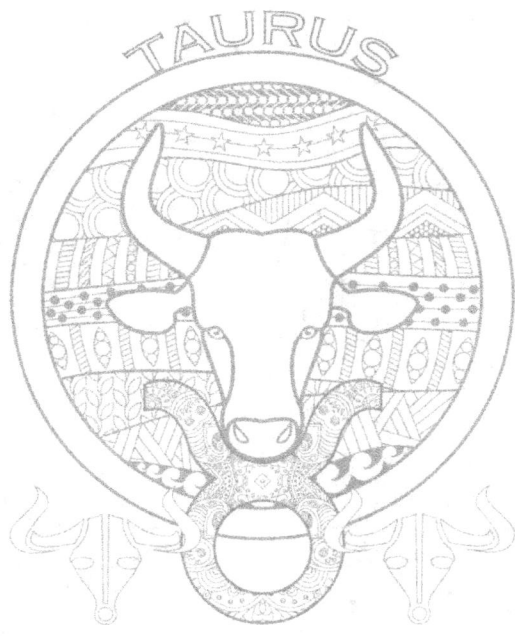

A comfy place to sit while enjoying the winery's finest is heavenly.

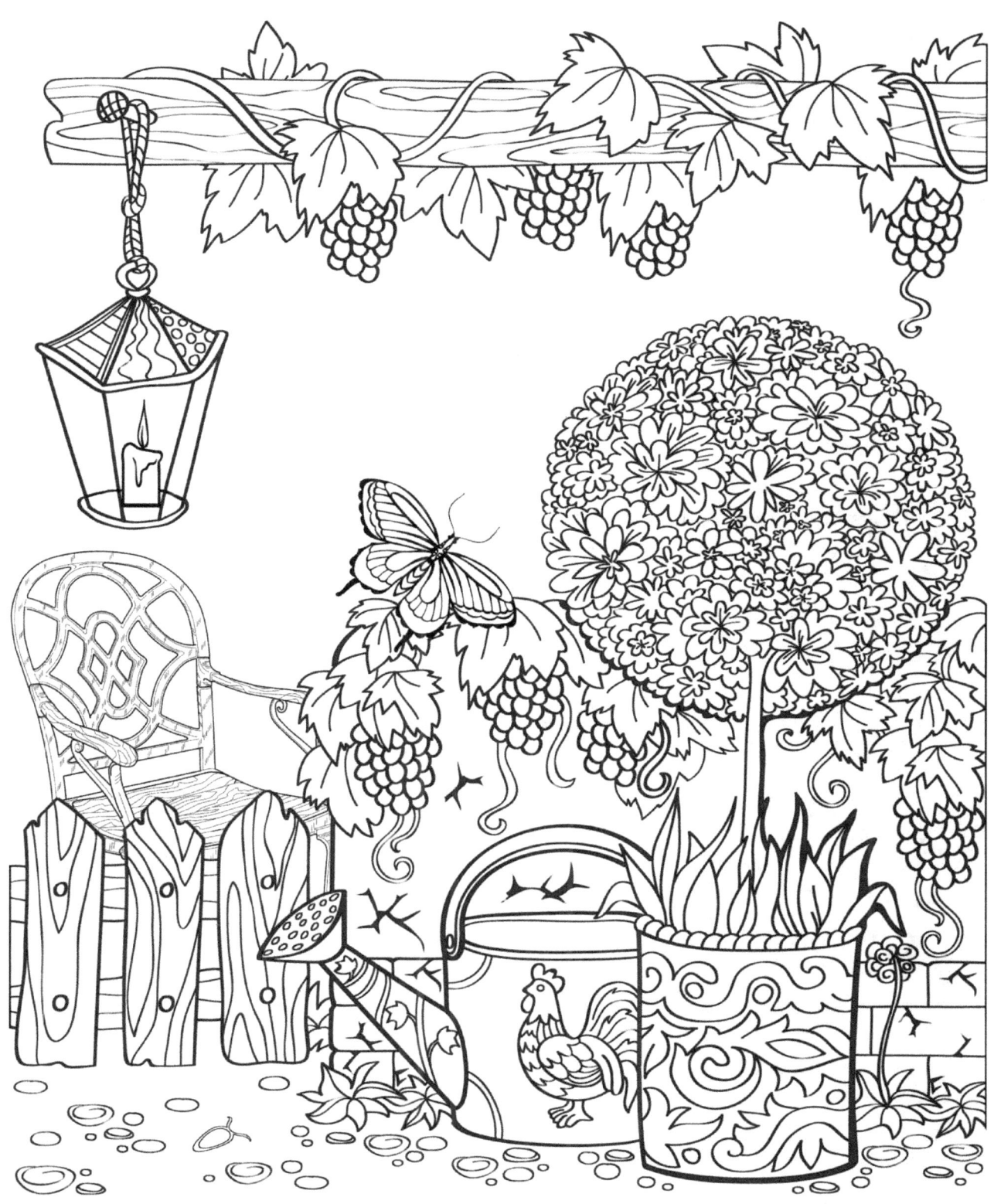

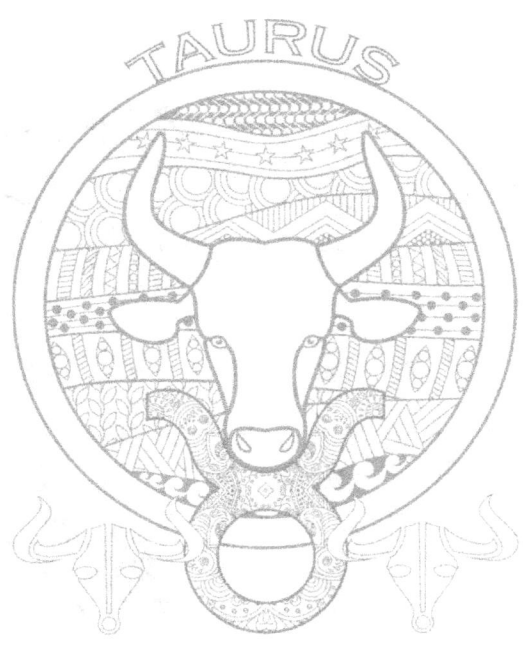

Dogs are a great and faithful companion to Taurus who values loyalty. A dog for Taurus will be their best friend for life.

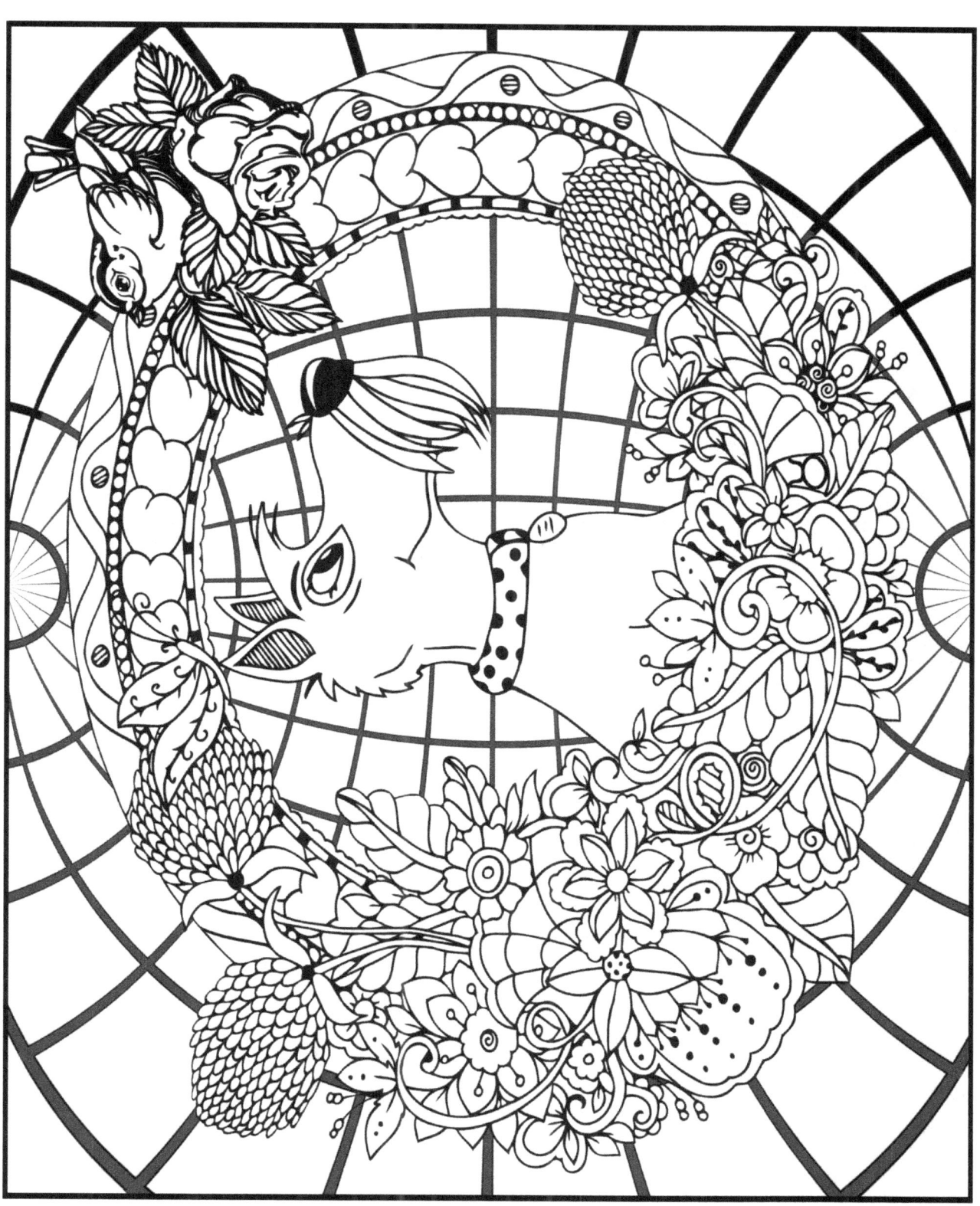

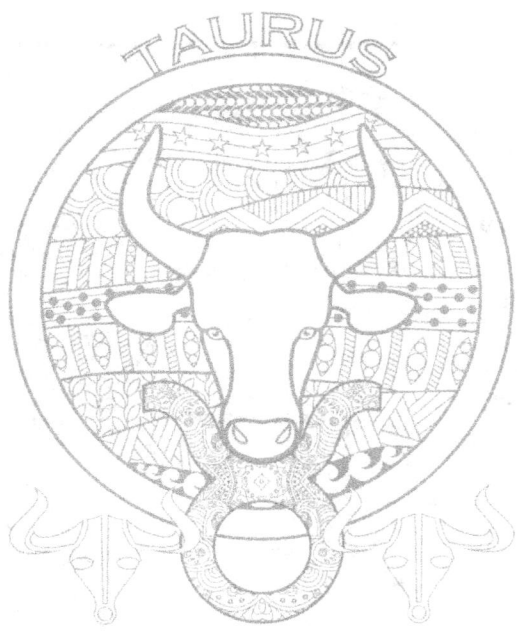

Ash is the tree that represents the Tree of Life. With its tall branches and vast root system it is not surprising that the Ash tree is associated with Taurus.

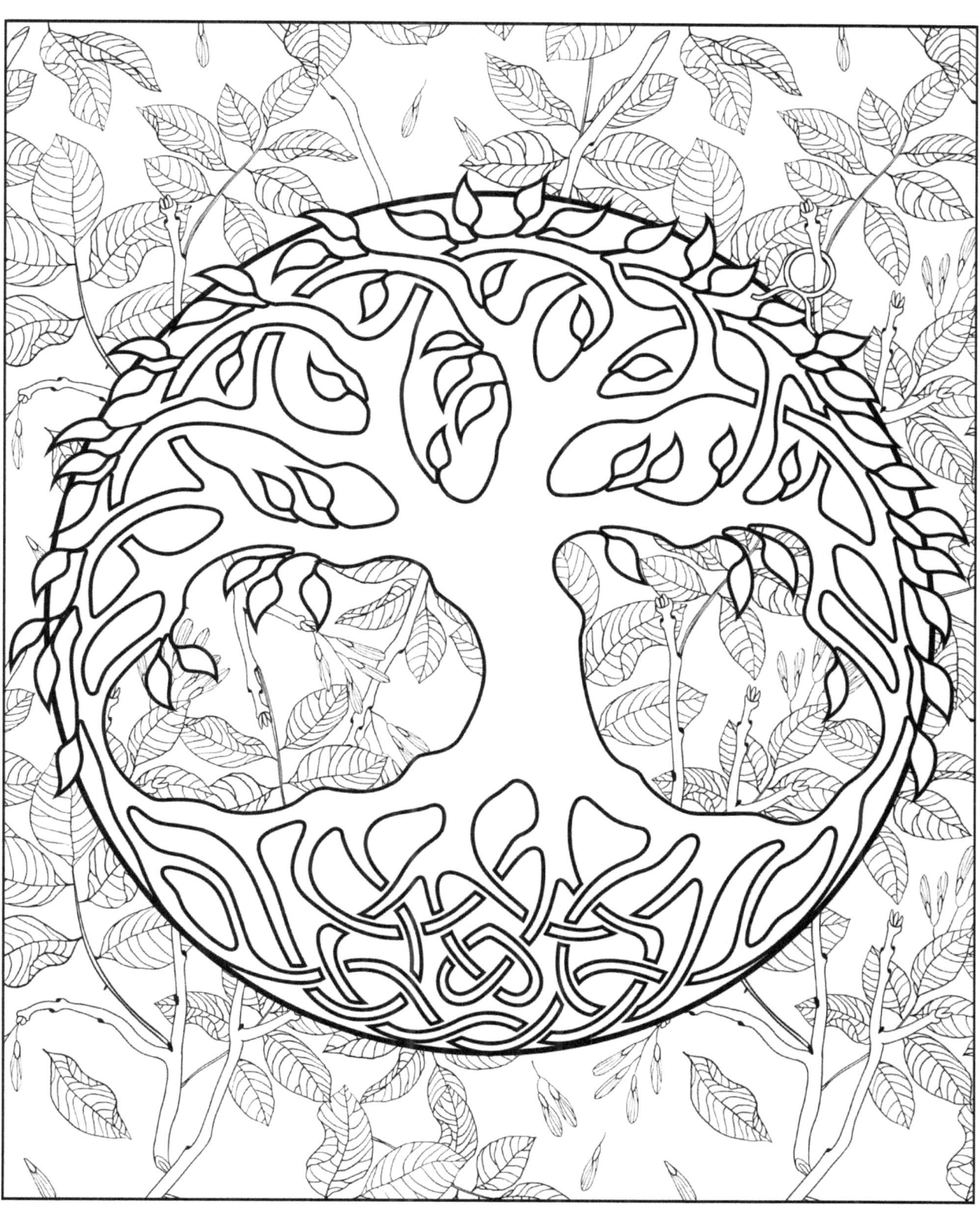

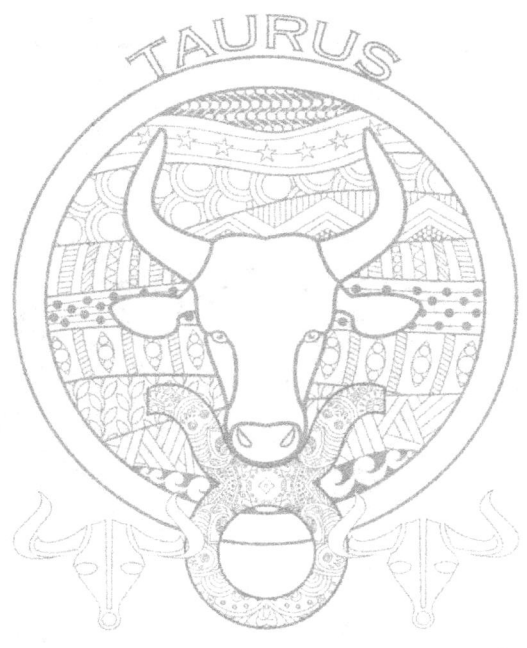

As the first of the 'Earth' signs, Taurus personifies the expressions 'solid as a rock' and 'down to earth'.

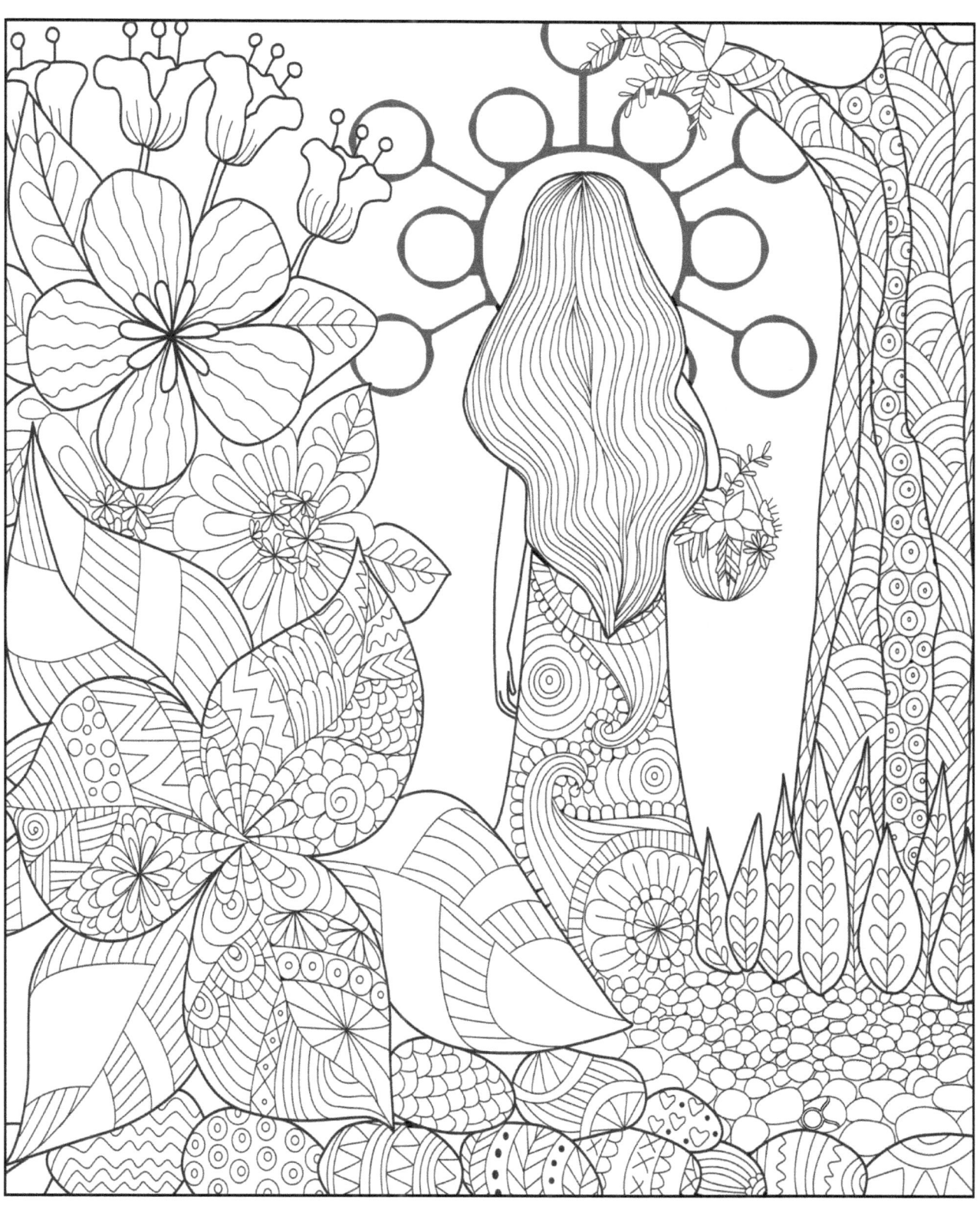

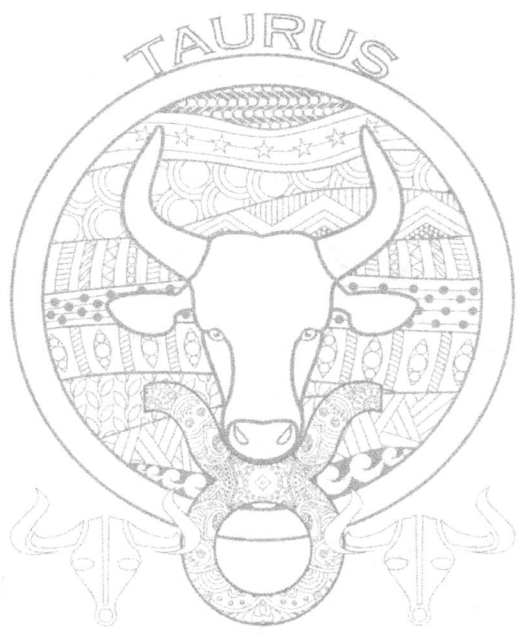

To the outside world a Taurus may appear completely composed, but inside, they are hopelessly romantic and looking for that "love of a lifetime."

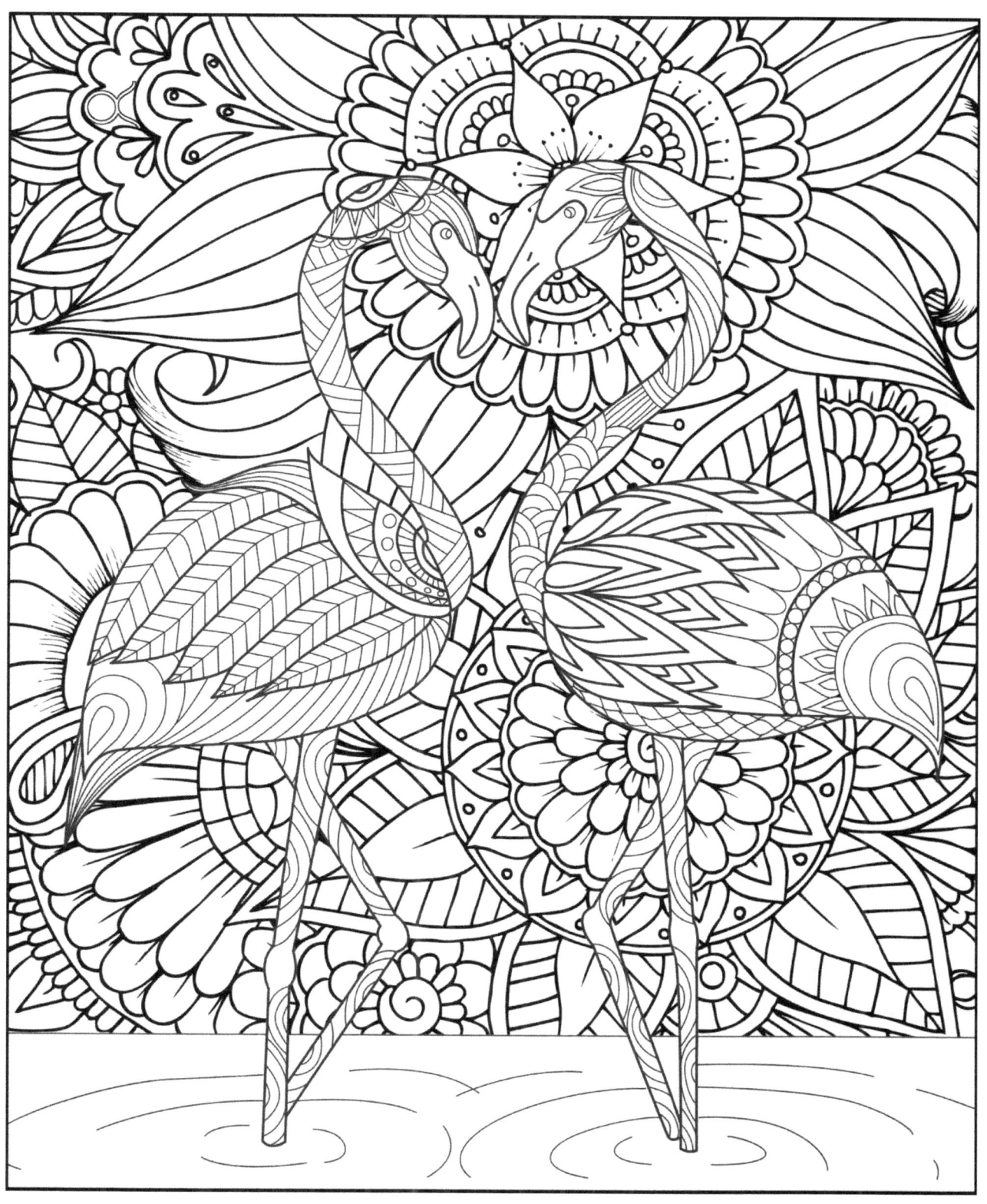

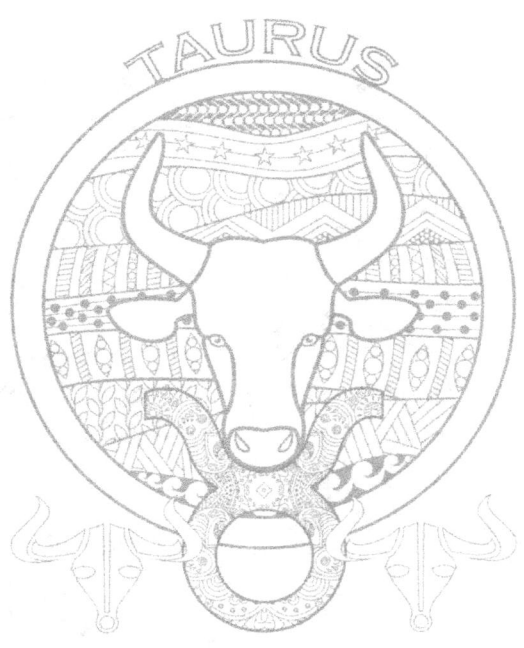

The close to earth Taurus has basic needs for love - a solid and stable (rooted), loyal partner who's affectionate and classy.

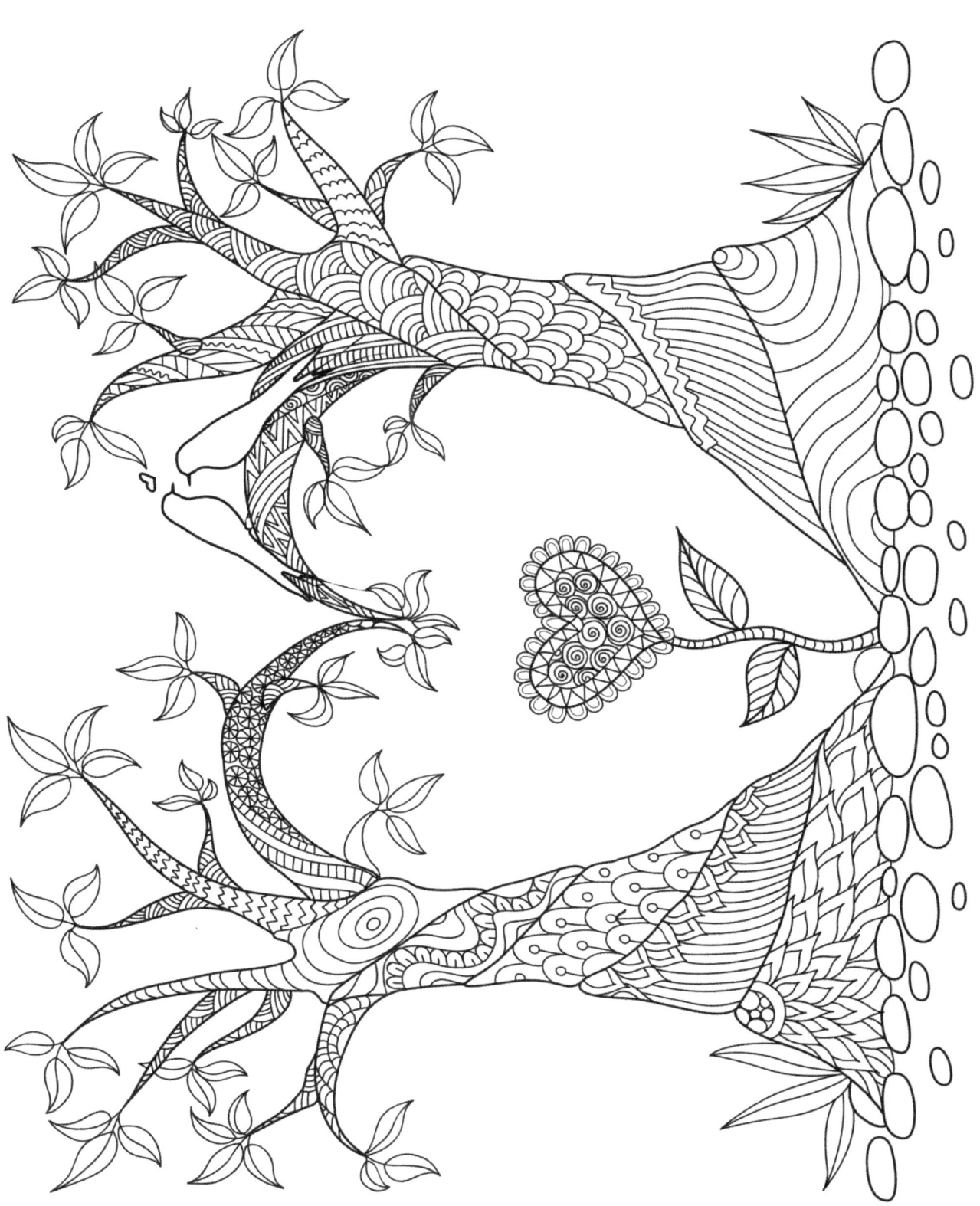

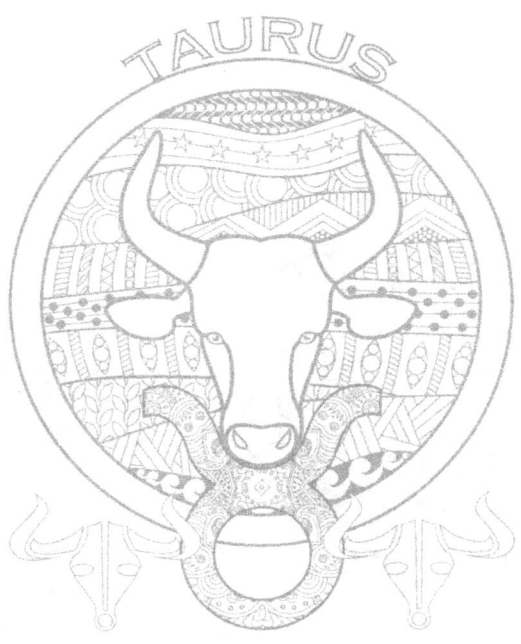

Taureans can seem like showoffs, but really, they just like to feel successful and be surrounded by beautiful things.

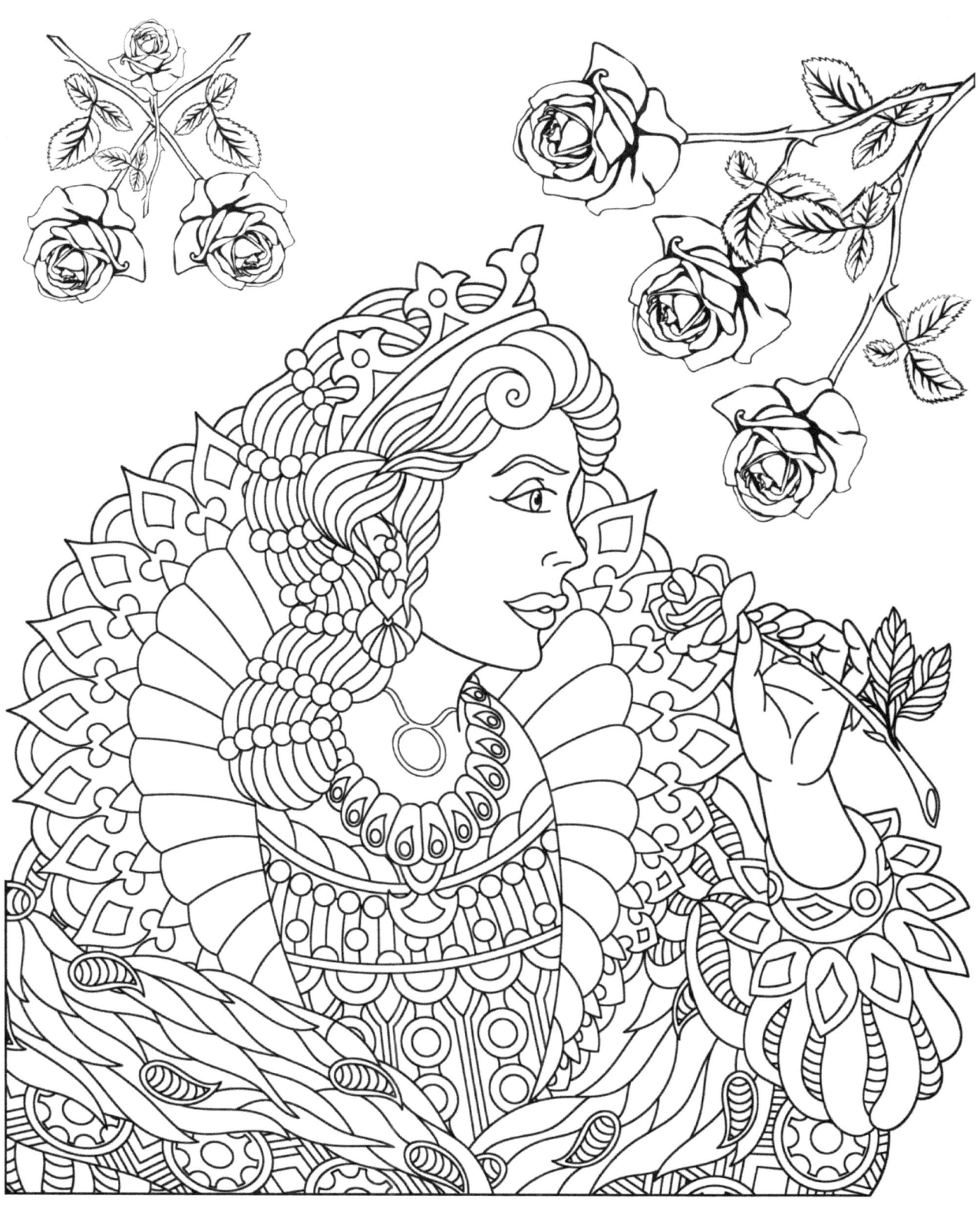

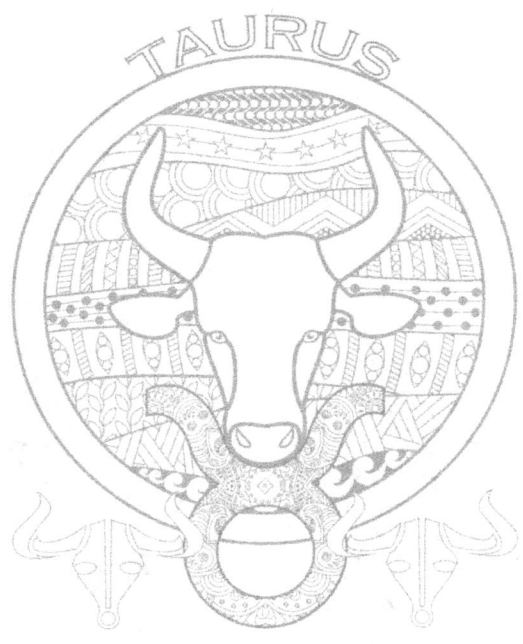

Taurus people are considered to be hard to get moving but nearly impossible to stop once moving.

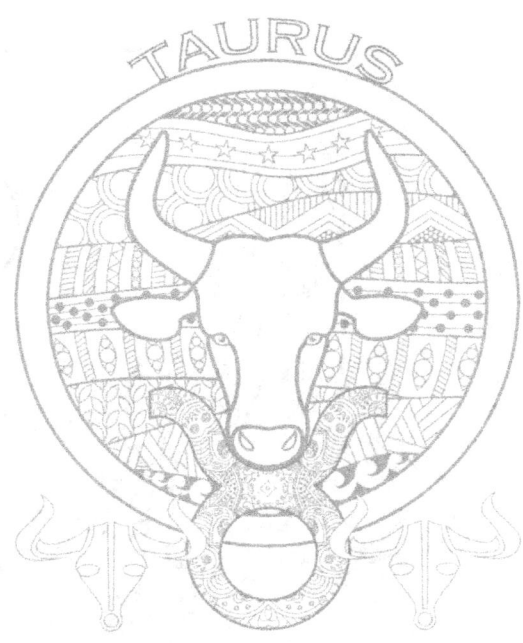

Taurus is symbolized by the bull representing strength, tenacity, virility, and power. Left alone, a bull will happily graze; but if it is bothered, it will charge!

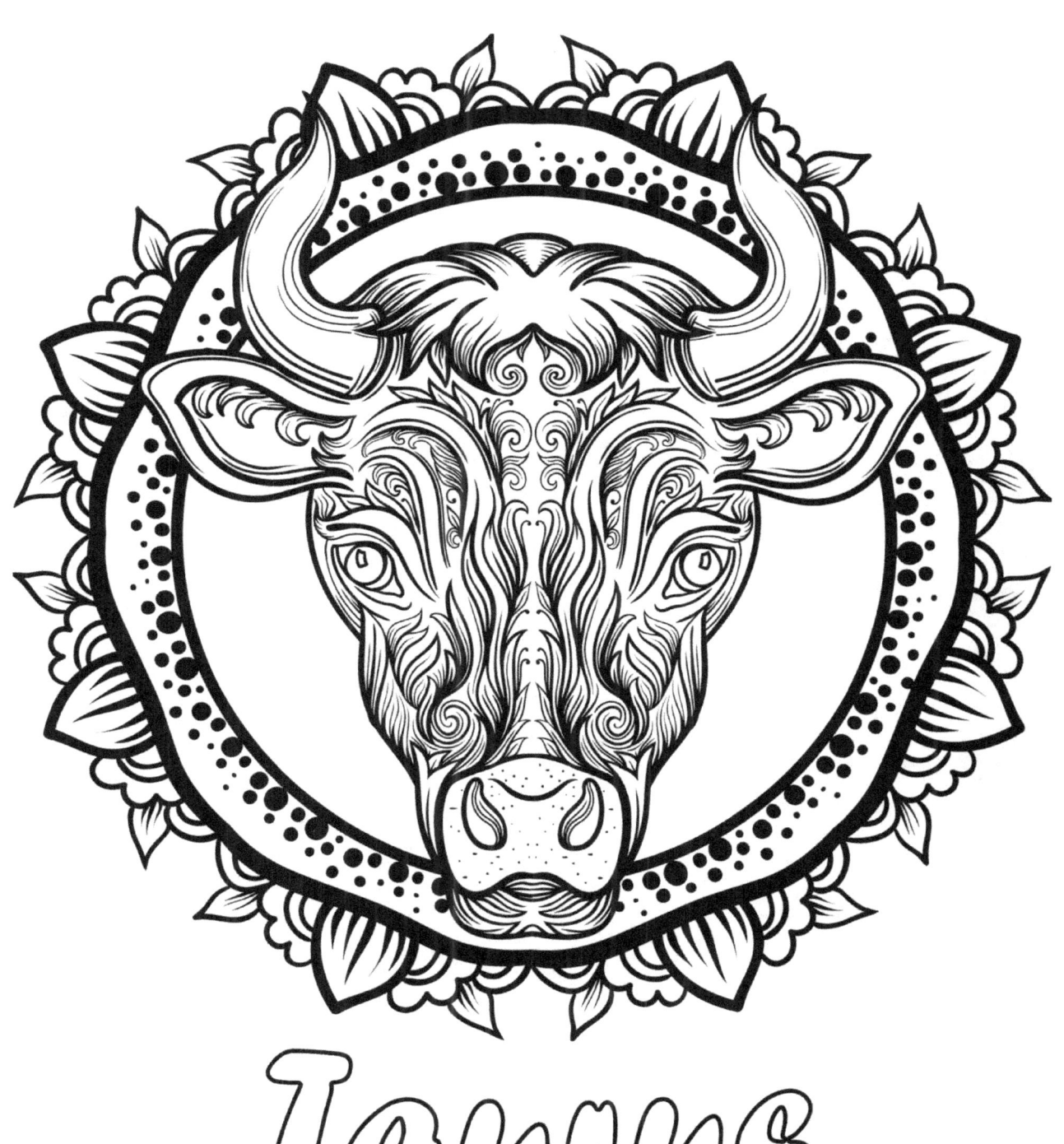

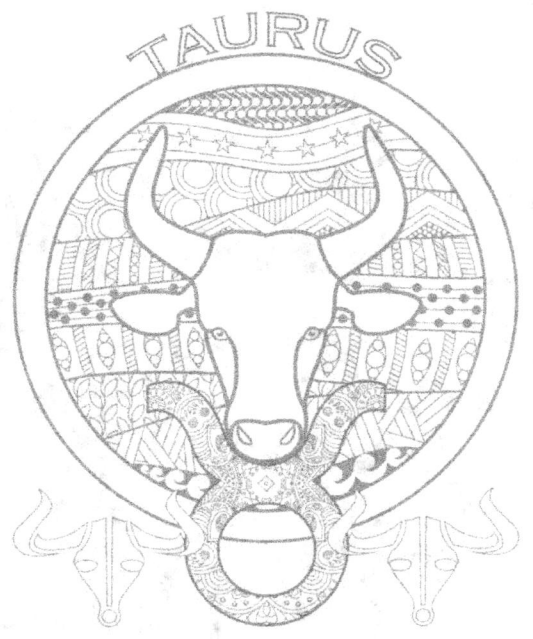

SPECIAL DISCOUNT!

Many customers would like to color some of the coloring pages more than once. If you're one of them we have something special to share with you…

You can get the downloadable pdf version of this book at a special discount because you have purchased this book. You can download the book and print any coloring page as many times as you would like.

To take advantage of this offer simply:

1. Go to the product page:
 https://mytimetocolor.com/tauruspdf
2. Add the pdf version to your cart
3. Click on Checkout (cart icon)
4. Enter the coupon code: pdf02zt
5. Complete Checkout
6. Download book and print your favourites!

CONNECT WITH US!

We'd love to connect with you so please visit the website or like us on Facebook!

Website:

www.MyTimeToColor.com

Facebook:

http://Facebook.com/mytimetocolor

POST A REVIEW

Your review means a lot so please consider taking a moment and posting a review on Amazon. Thanks!!

www.ingramcontent.com/pod-product-compliance
Lightning Source LLC
Chambersburg PA
CBHW081205180526
45170CB00006B/2216